FUCK OFF, I'M COLORING!

Unwind With 50 Obnoxiously Fun Swear Word Coloring Pages

DARE YOU

STAMP CO.

A belligerent subset of
Cider Mill Press Book Publishers

CIDER MILL PRESS

BOOK PUBLISHERS

KENNEBUNKPORT, MAINE

13-Digit ISBN: 9781604336610
10-Digit ISBN: 1604336617

This book may be ordered by mail from the publisher. Please include $5.99 for postage and handling.
Please support your local bookseller first!

Books published by Cider Mill Press Book Publishers are available at special discounts for bulk purchases in the United States by corporations, institutions, and other organizations. For more information, please contact the publisher.

Cider Mill Press Book Publishers
"Where good books are ready for press"
PO Box 454
12 Spring Street
Kennebunkport, Maine 04046

Visit us on the Web!
www.cidermillpress.com

Typography: Fairytale, Festivo Letters No. 11, Archive Tilt,
Satisfy, and Adobe Garamond Pro

Printed in the USA

19

IF you've gotten this far, then you're our kind of fucker!
Or perhaps you're already a fan of our little Dare You Stamp
Company because we've long been producing irreverent
products that support voicing the rebellious chord in each of us.

Whether you've used our FU Stamp Kit on that denied insur-
ance claim, or sent your egotistical ex one of our "You Suck"
postcards, you know we firmly believe in free speech, free
expression, and especially the inalienable right not to be F'd
with when we're coloring!

Color any number of these wildly "expressive" pages until
everyone else calms the fuck down or at least learns better than
to disturb you when you're working on your masterpiece! And
if they don't, well then, color any number of the following
pages and leave your handiwork on that annoying colleague's
desk, that shit-for-brains roommate's bed, or on the windshield
of that driver who took up two parking spaces. Even if your
world is running smoothly, and you couldn't be happier, think
of the laughter your friends will have when you send them a
hand-colored page that says "Brilliant Bitch!" In fact, if you're
a true badass, tag it on social media with #FuckOffImColoring
and get the recognition you've always desired! Hell, we even
double-dog DARE you!

TABLE *of* CONTENTS

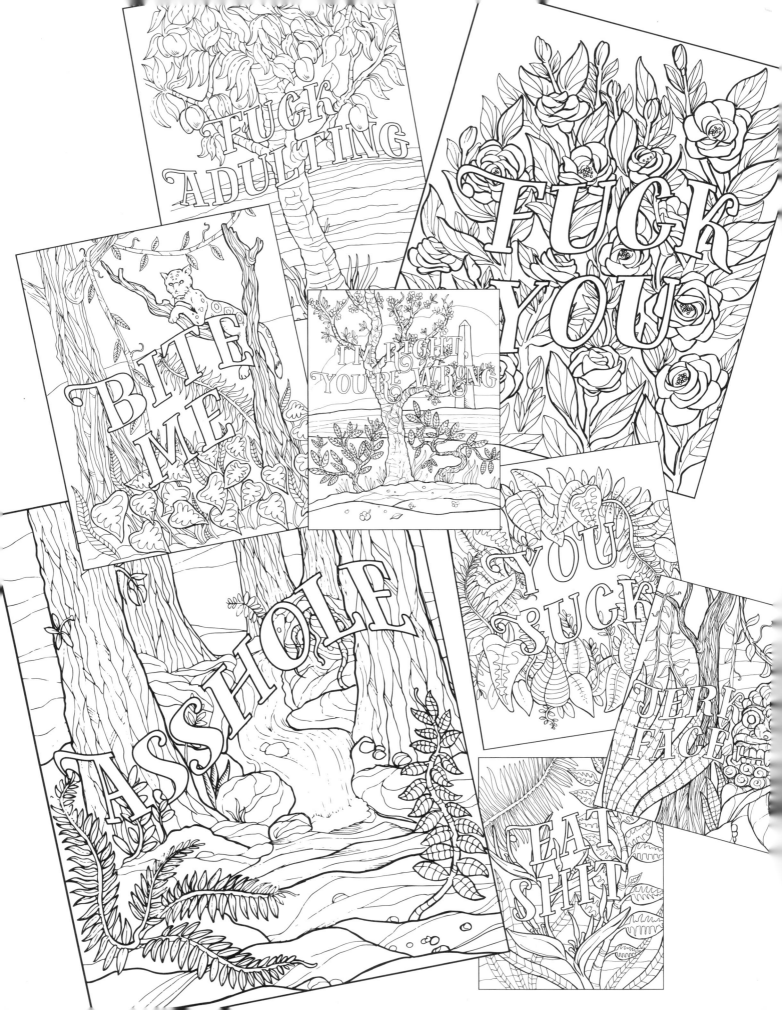

INTRODUCTION

Stressed out? Frustrated? Pissed off? We've got you covered… or, should I say, *colored*. We all know that the act of coloring unleashes some serious meditative power—putting colorful pen to intricately-designed paper has been calming us down since we were kiddos. So, why not get back to basics, return to what works, but add a little grown-up twist now that we're all adults here: some colorful language. Combine the calming act of coloring with the satisfaction of throwing around a good strong swear word, and feel your tension dissipate!

We've created swear-word coloring pages perfect for any situation that makes you want to let loose a string of curse words, from crappy co-workers to annoying exes, with phrases like Fuck This Shit and Over It. We've even created some awesome "Pump Me Up" coloring pages that let you unleash your inner badass by adding some color to phrases like Nailed It and I'm Fucking Awesome.

So, rather than screaming "Fuck Off!" from your cubicle and risk that dreaded visit to HR, take our approach to calming down—grab a marker, flip to any page, and let loose! Everyone else can just fuck off because, well, you're coloring!

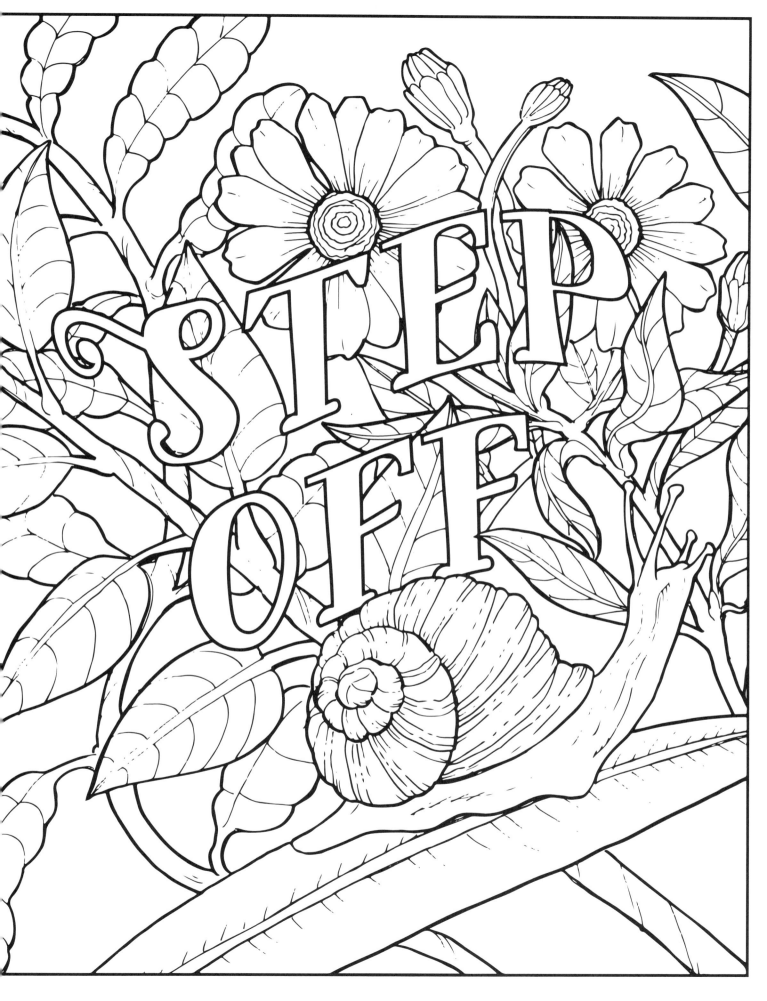

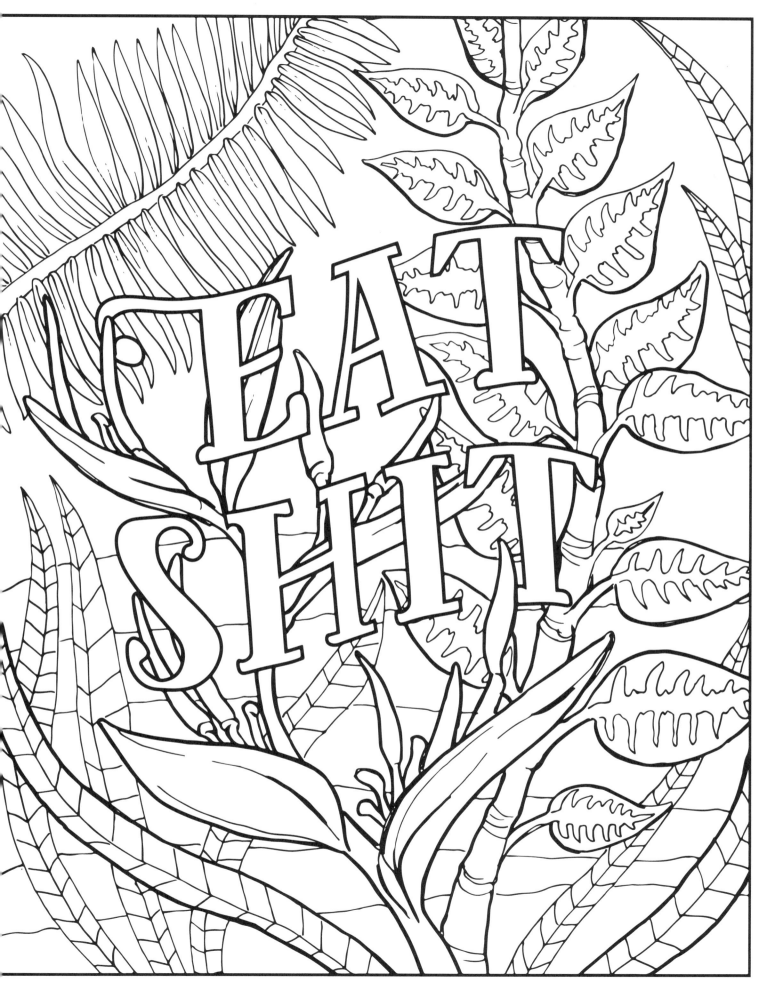

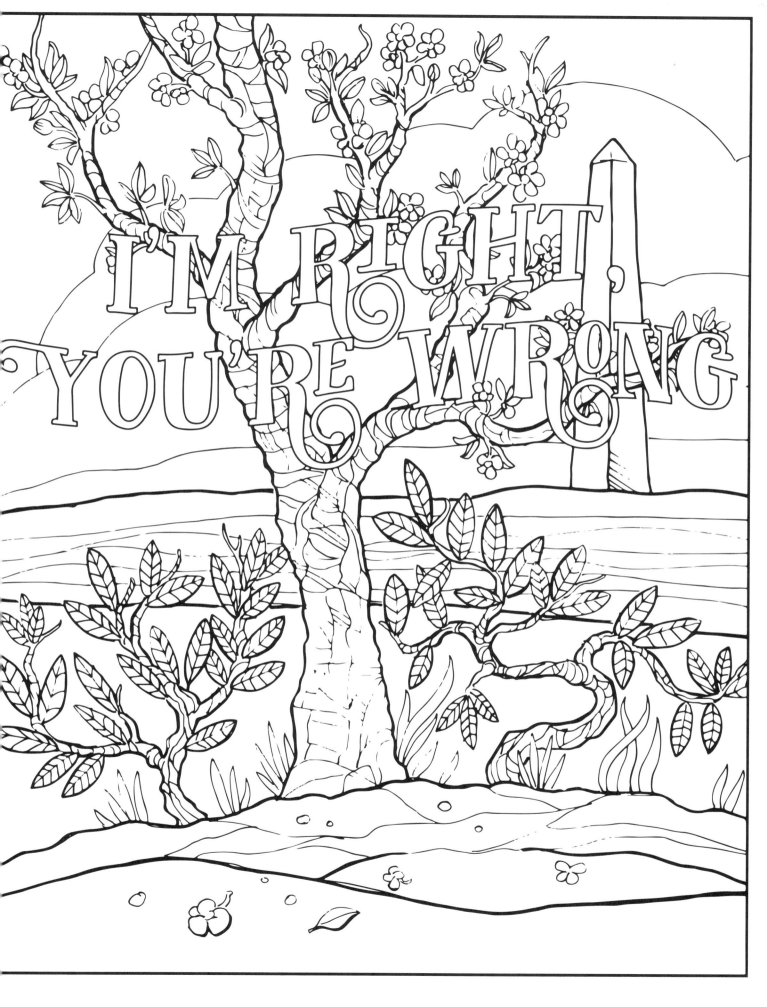

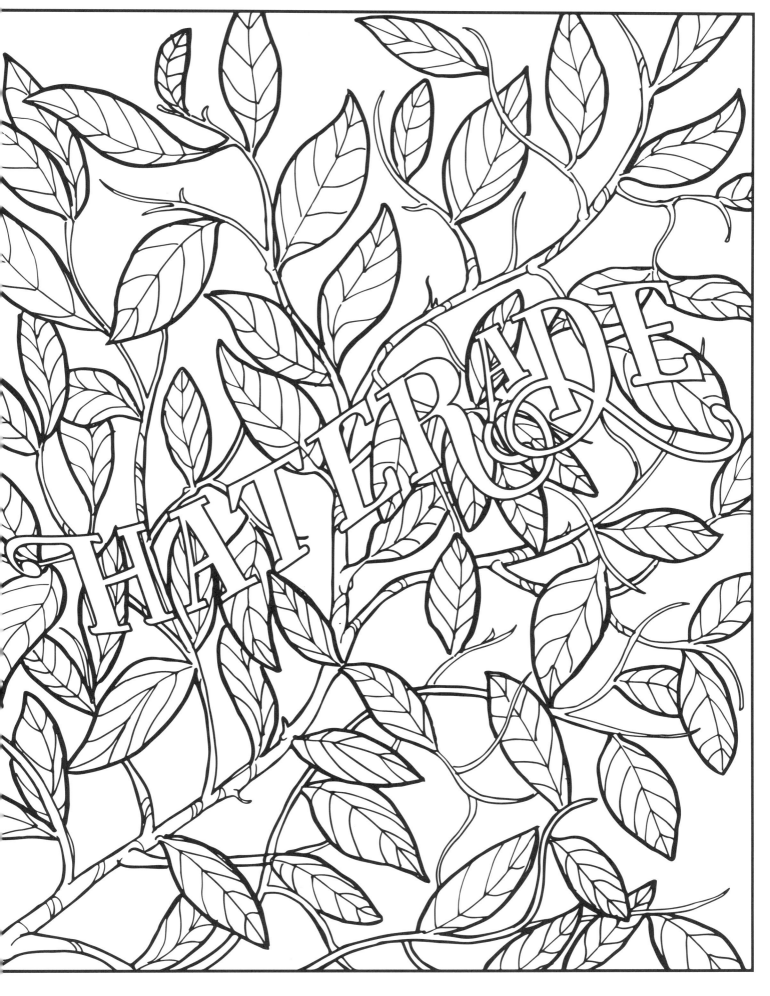

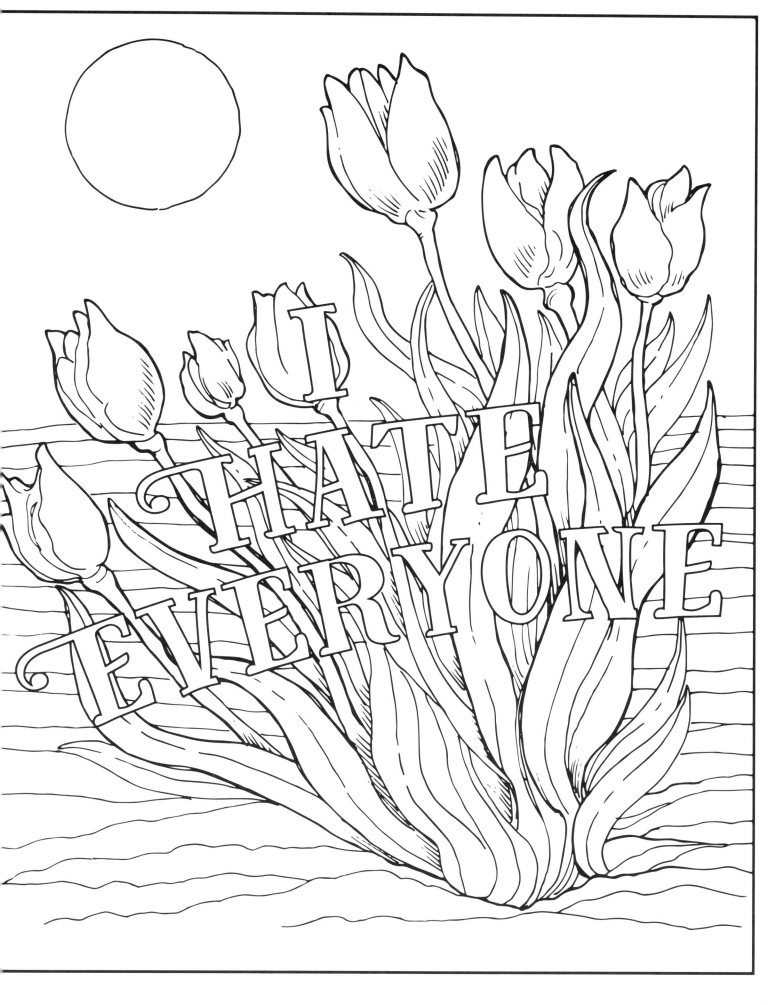

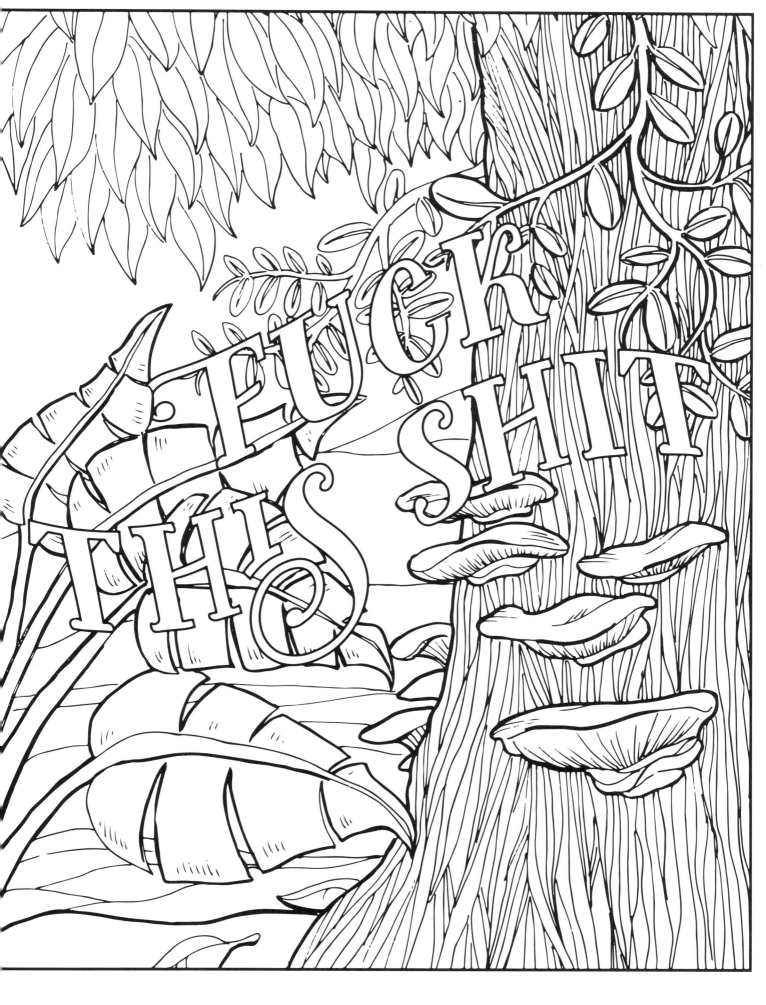

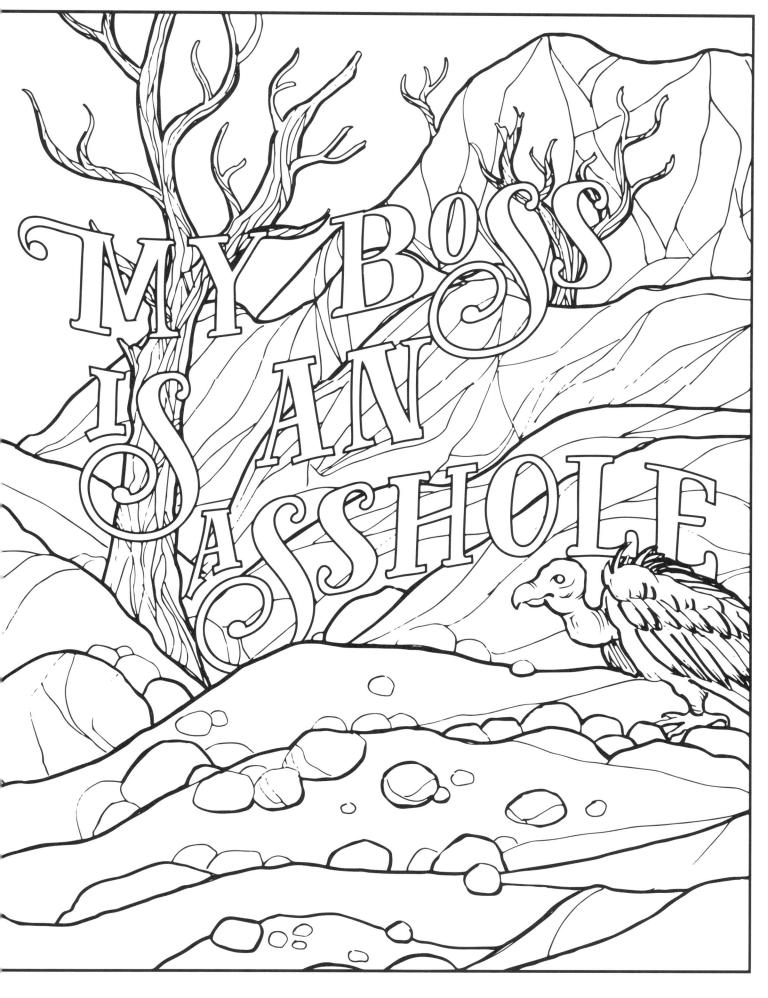

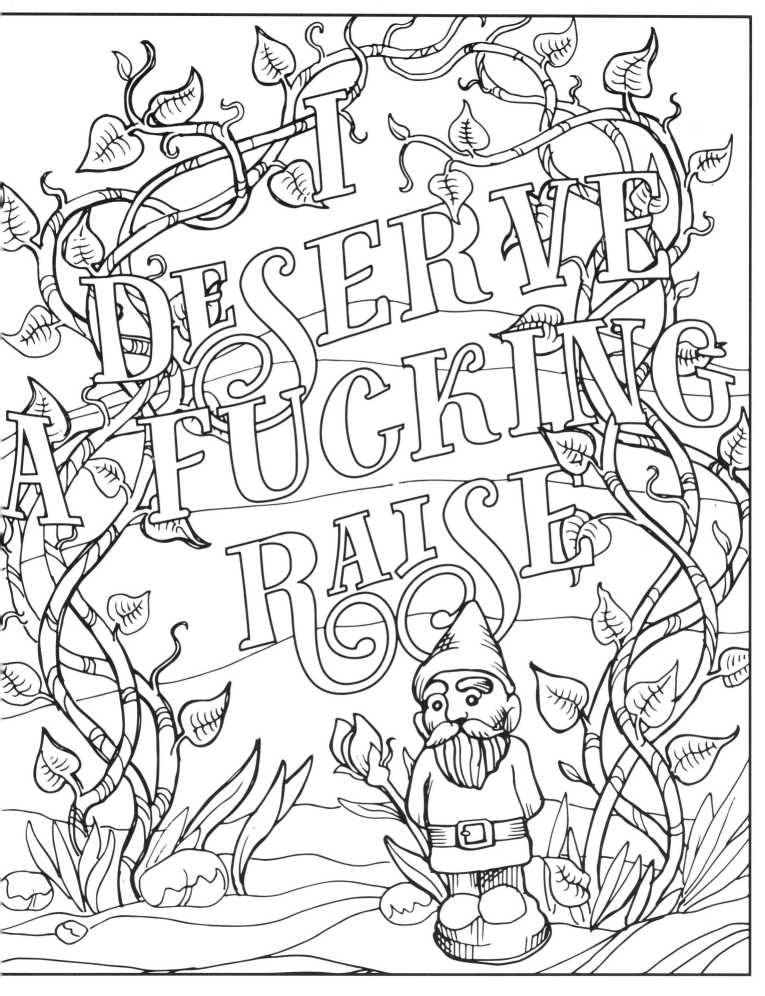

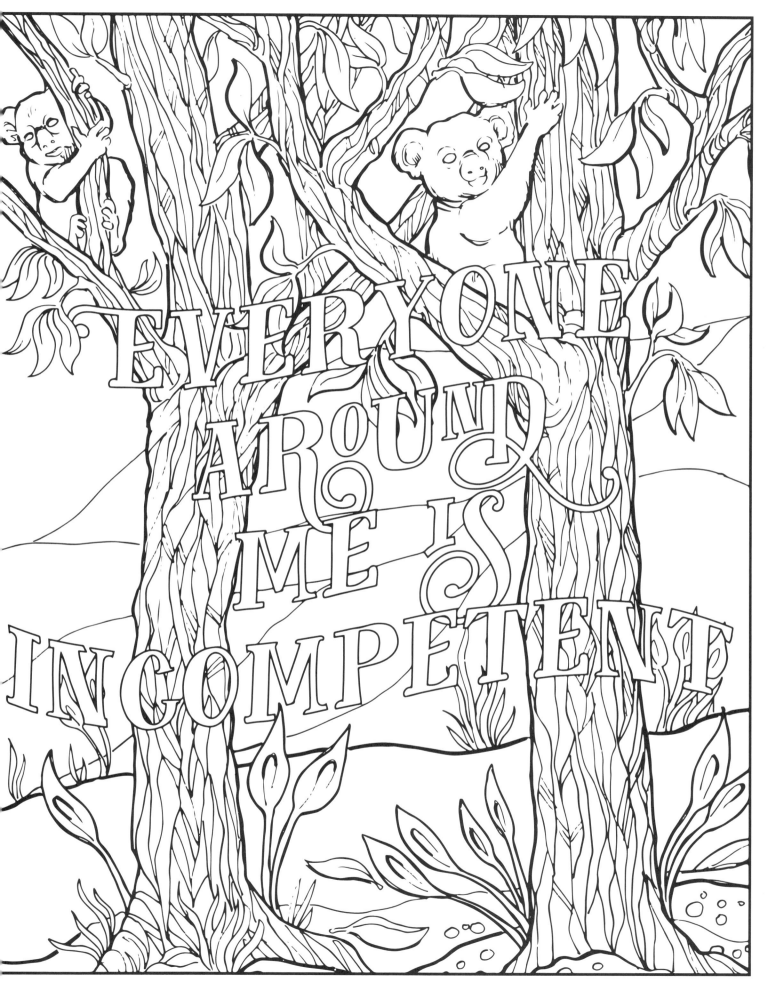

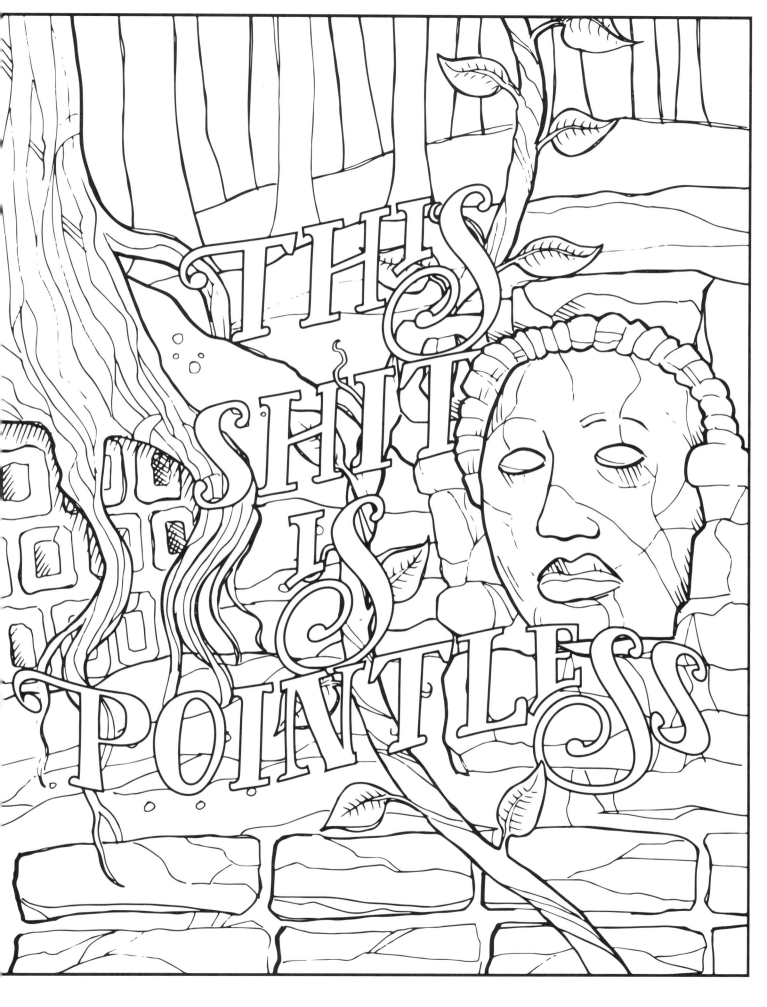

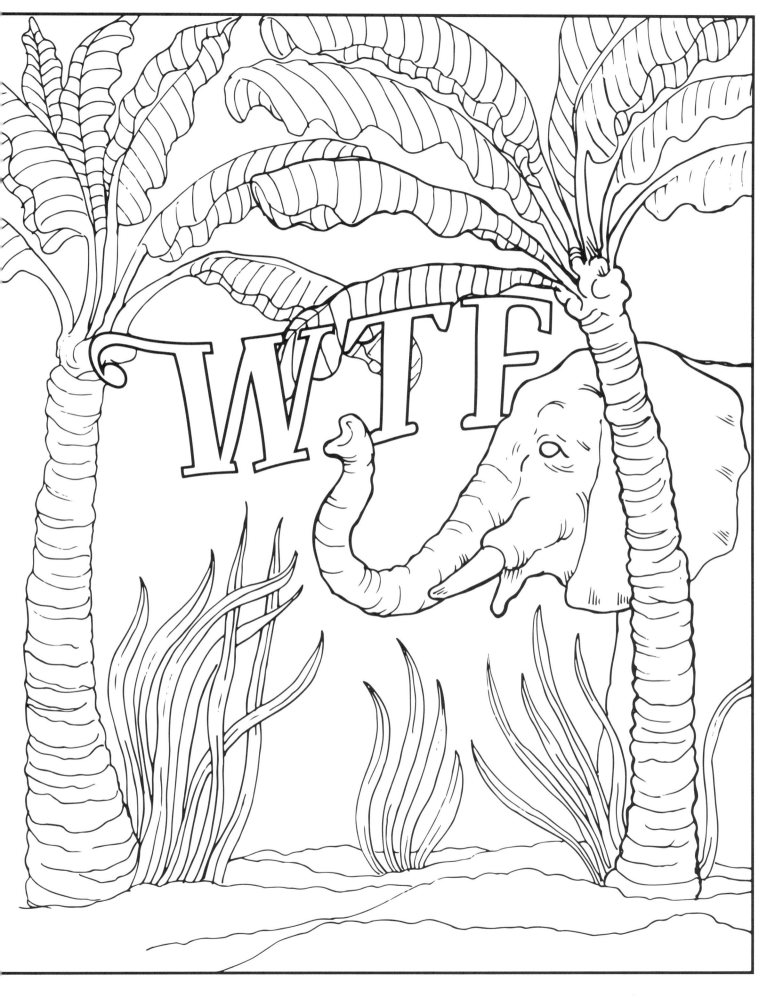

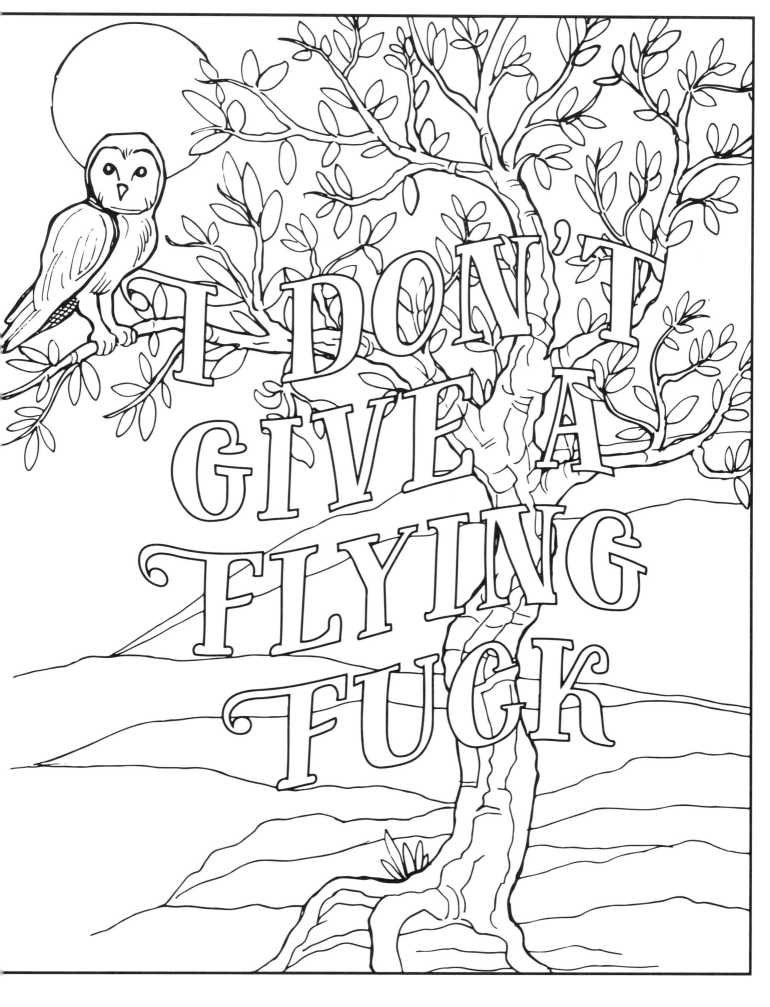

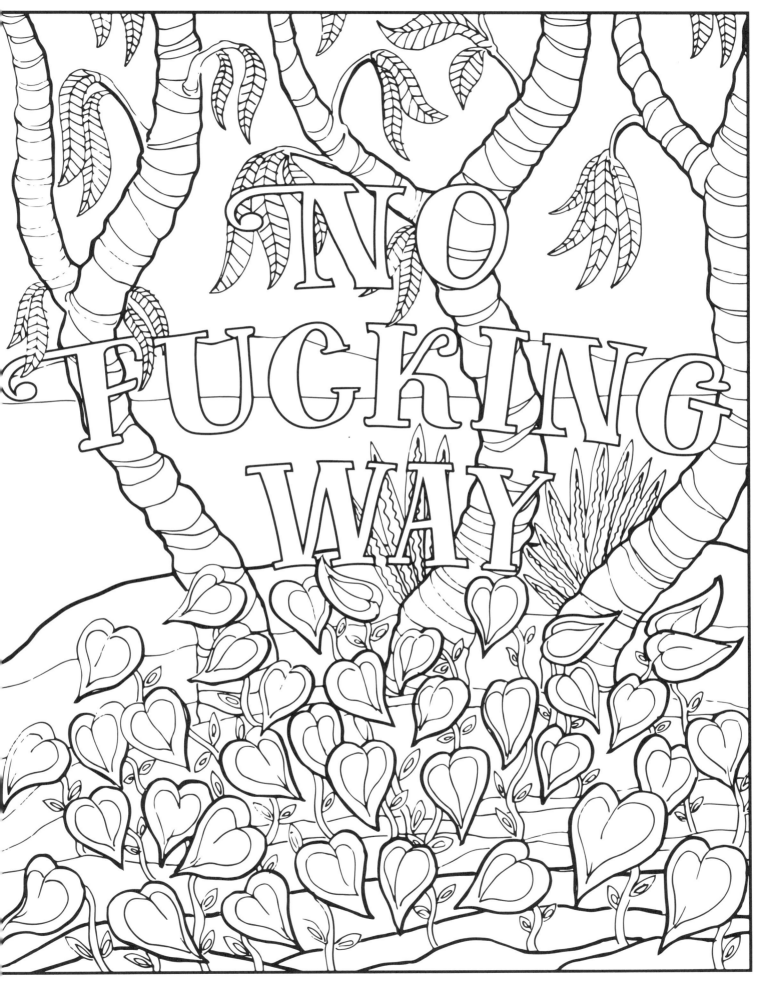

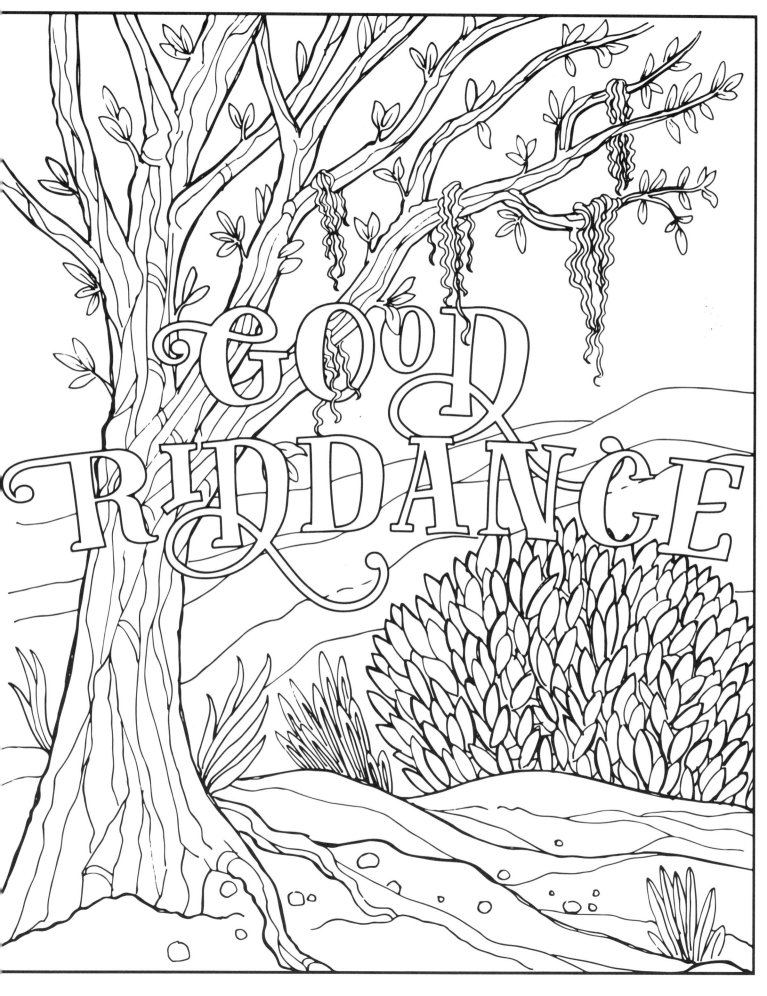

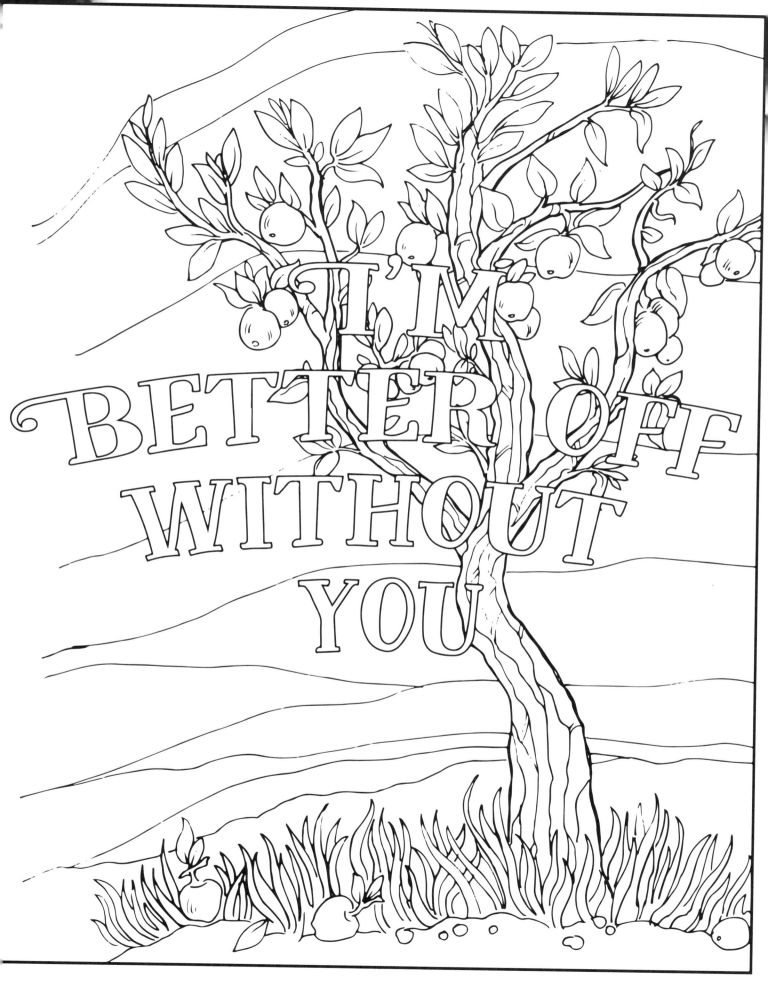

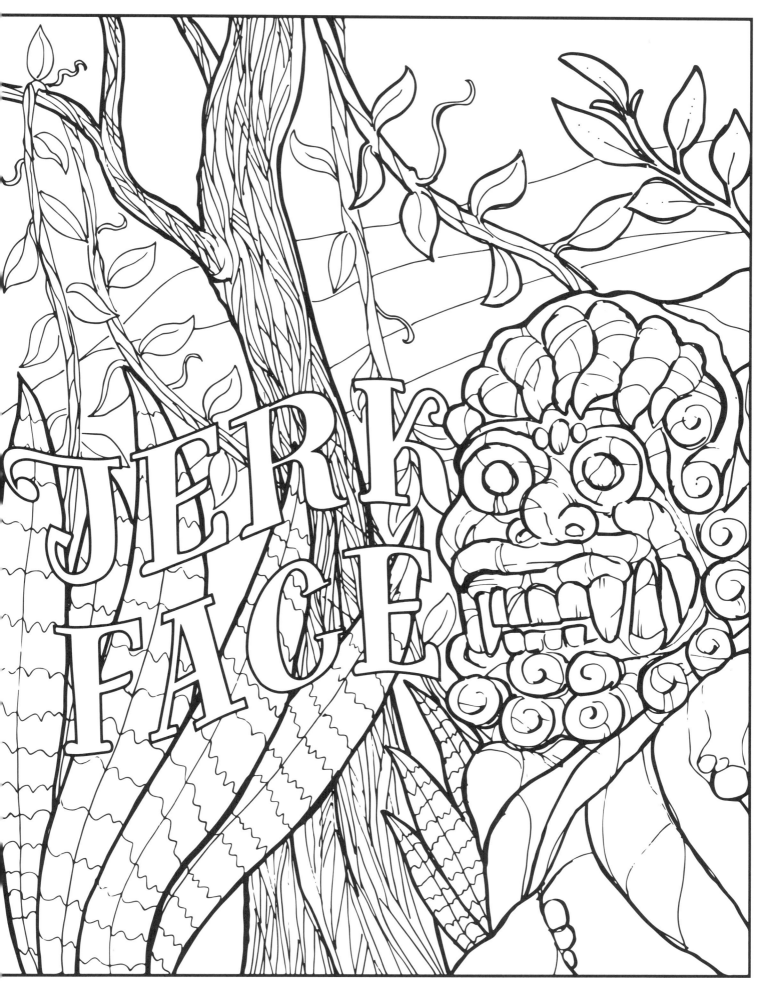

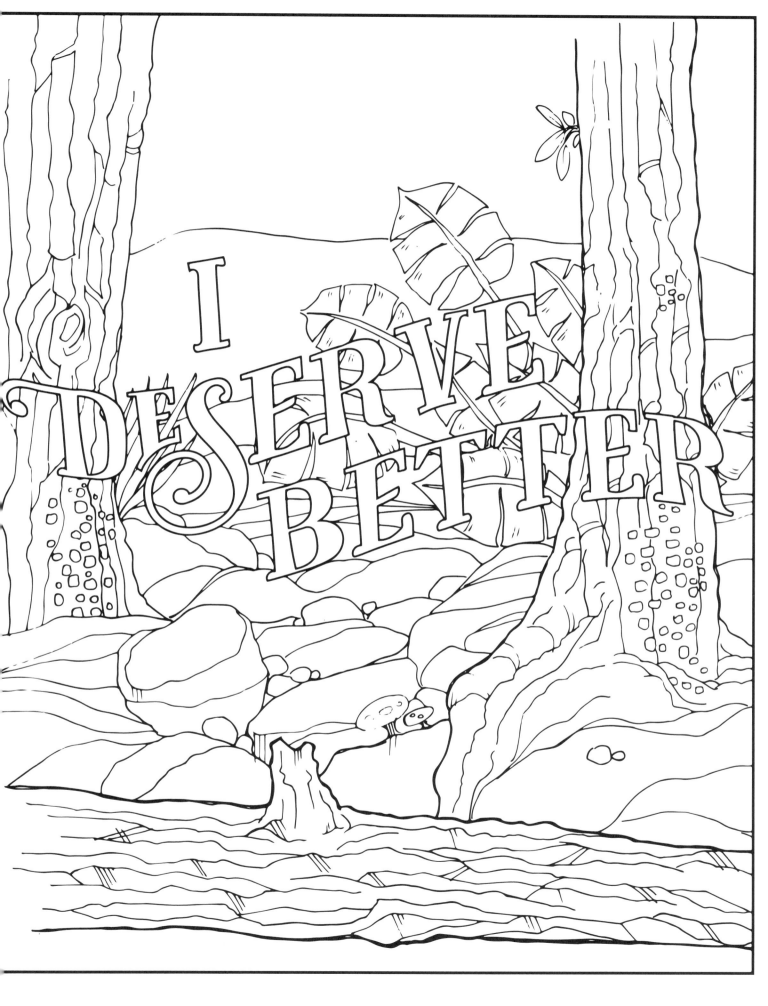

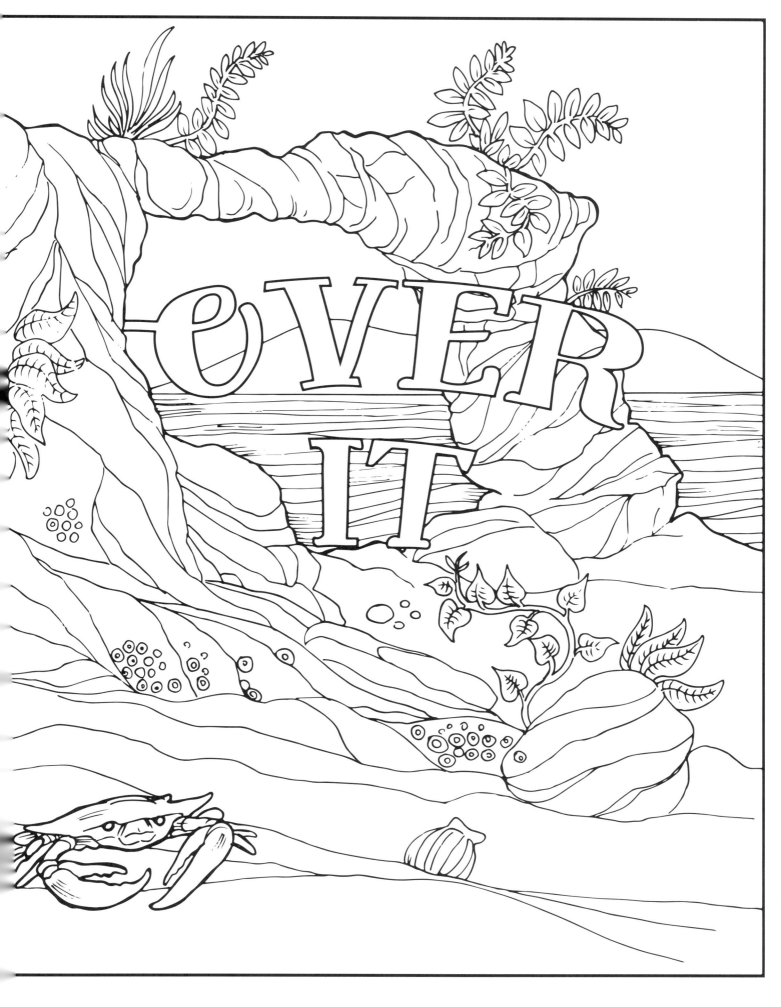

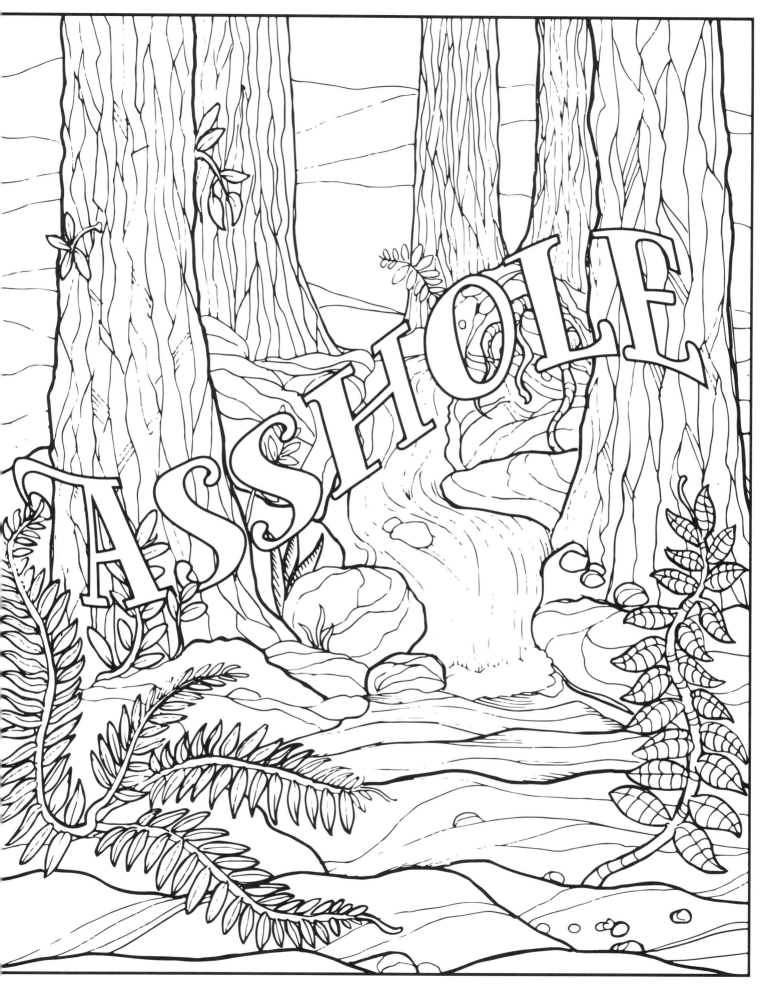

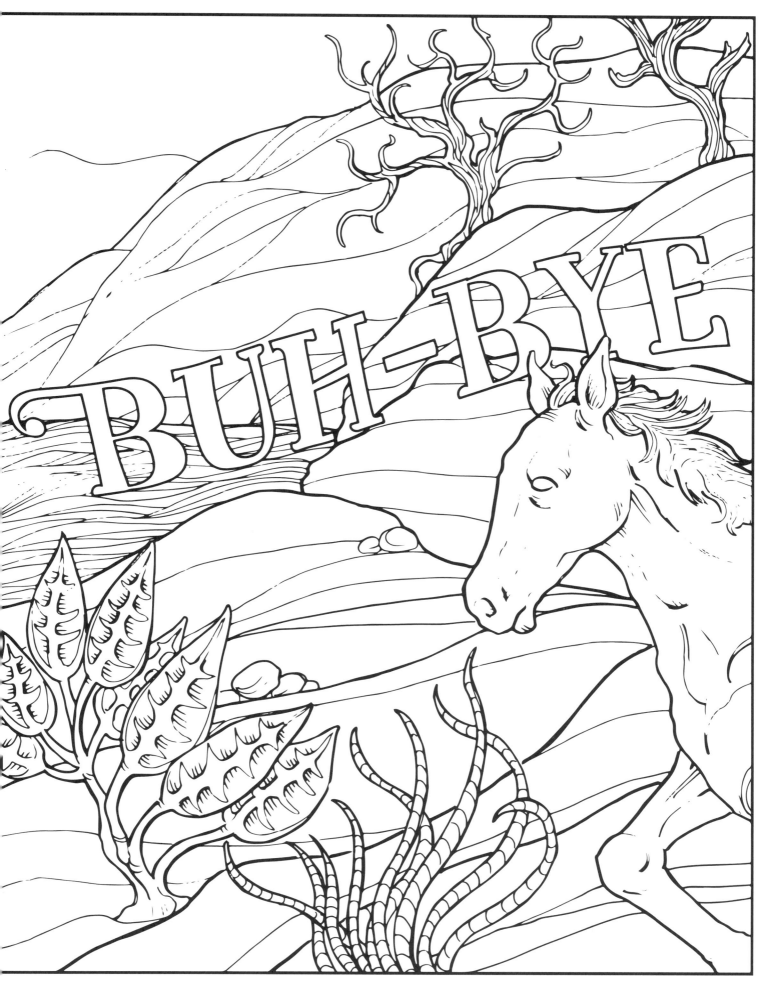

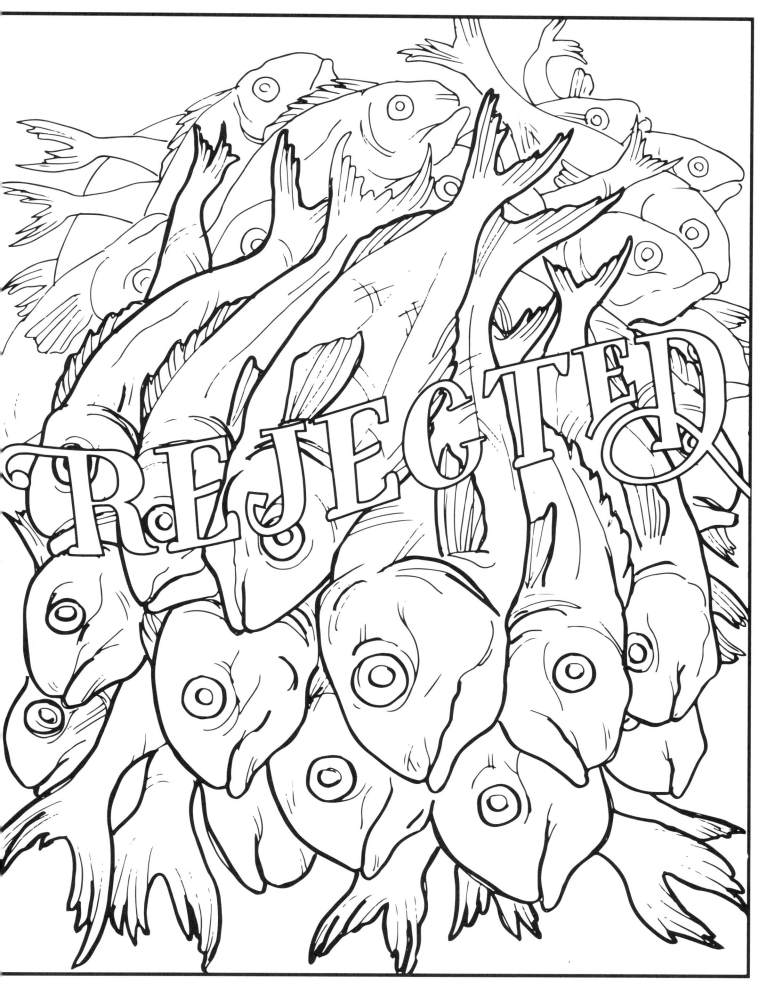

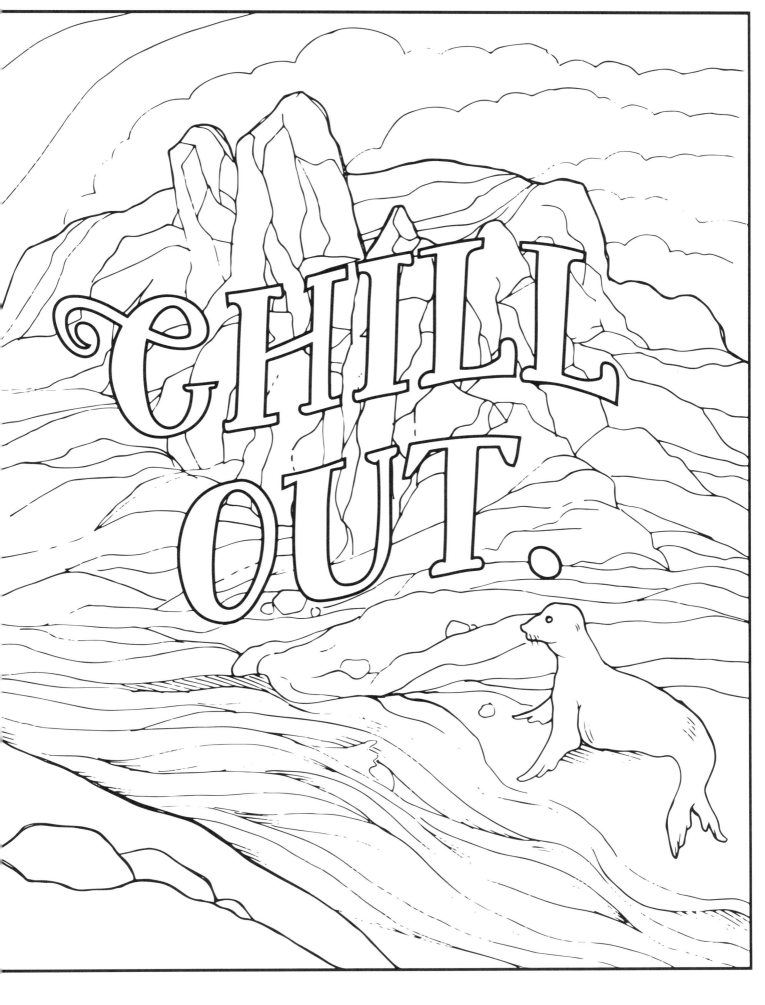

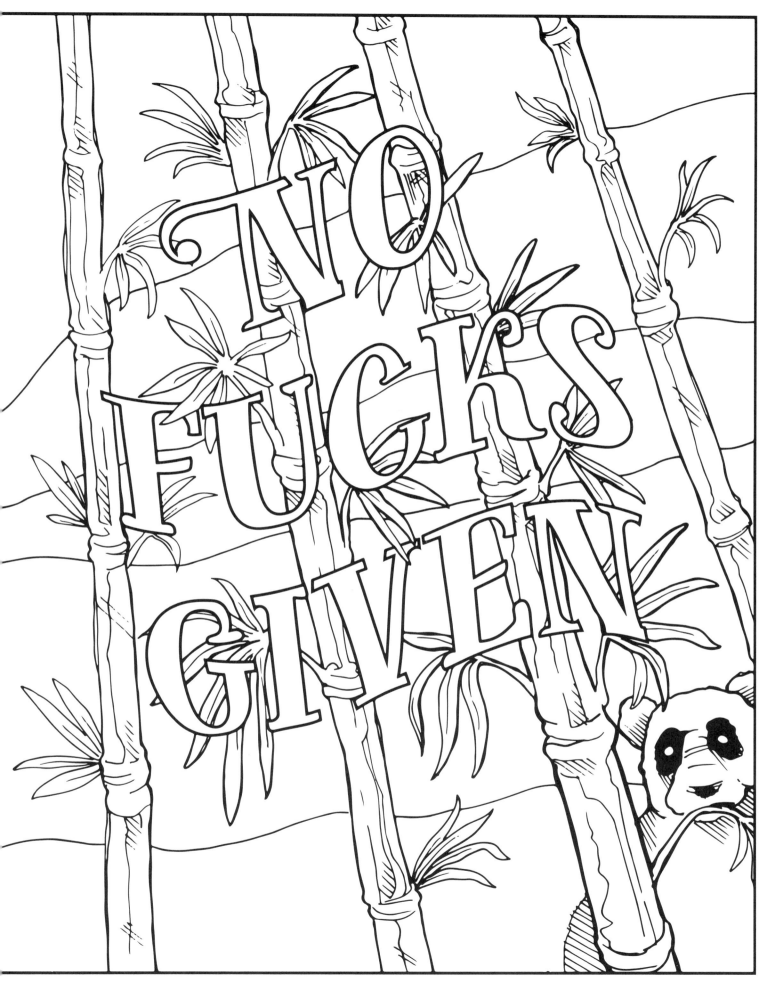

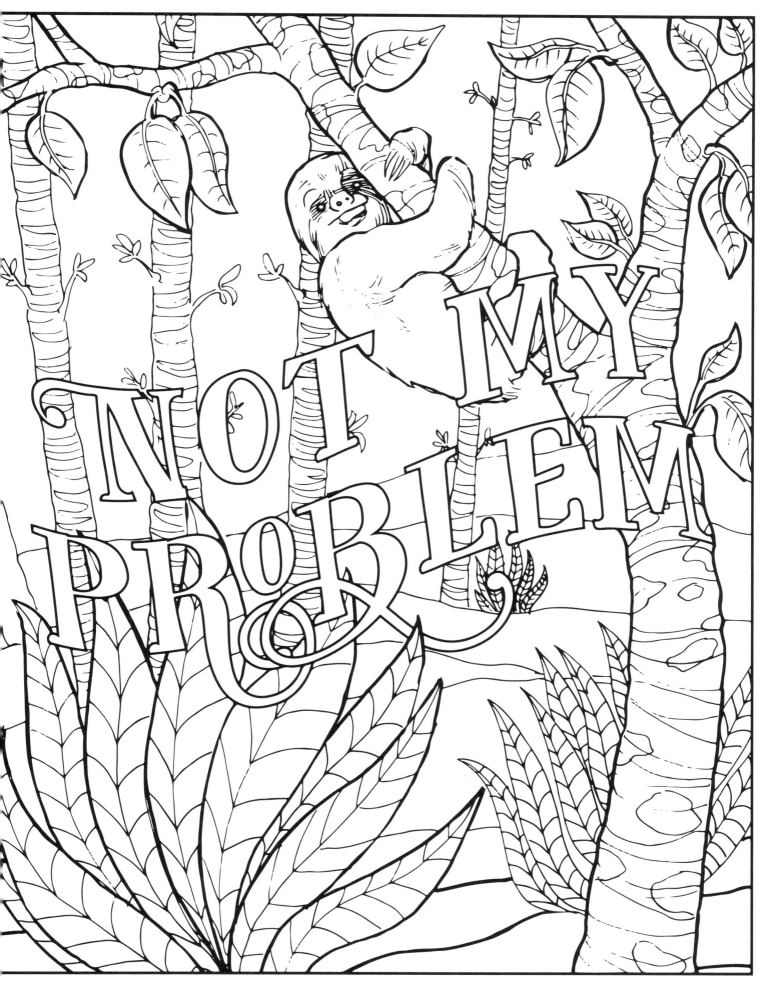

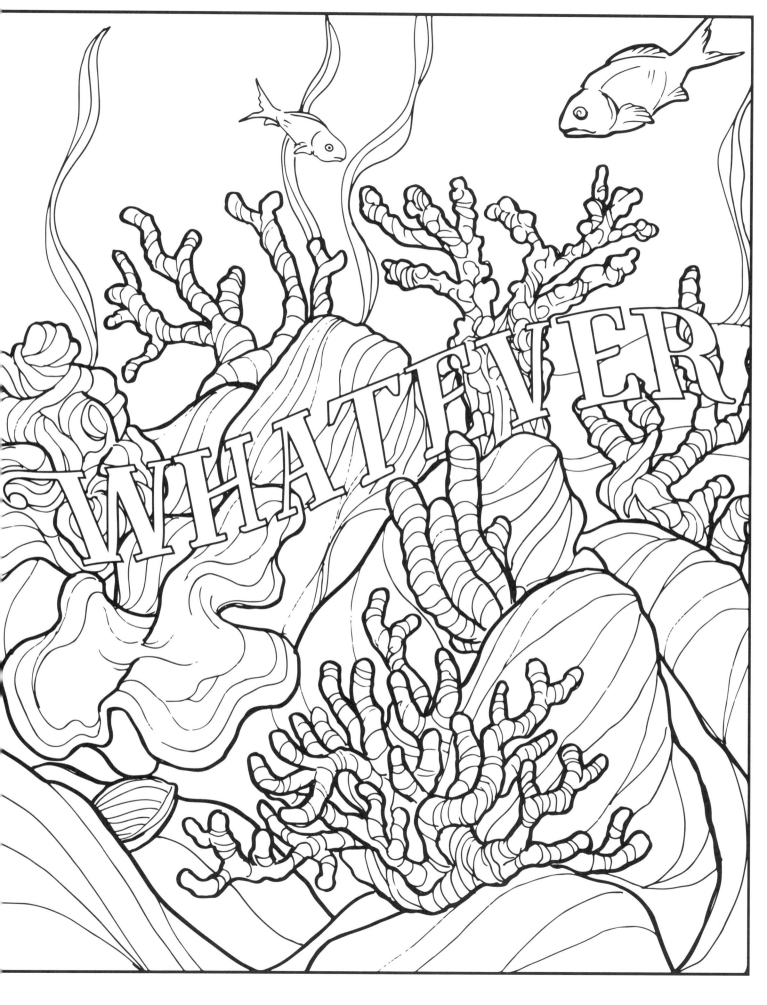

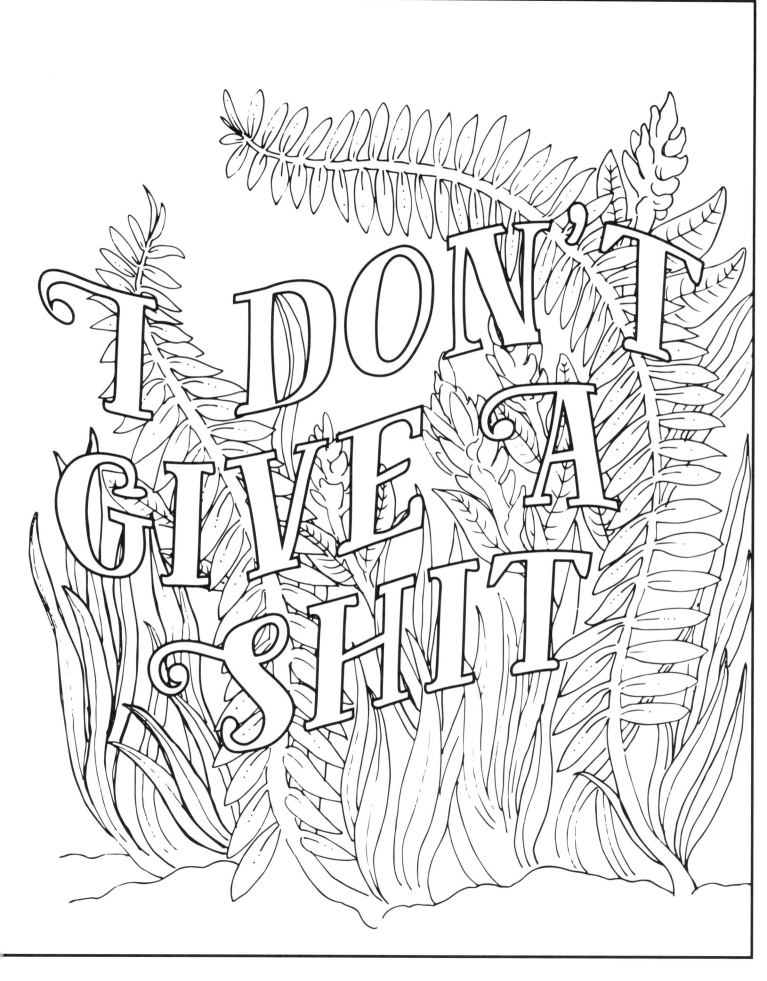

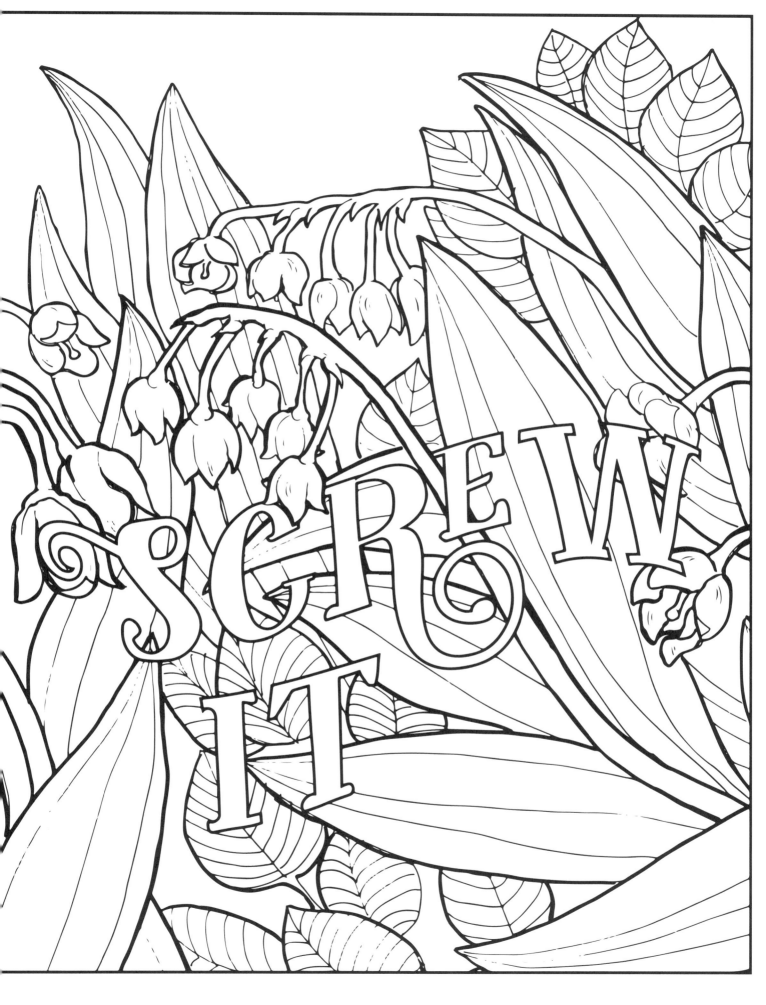

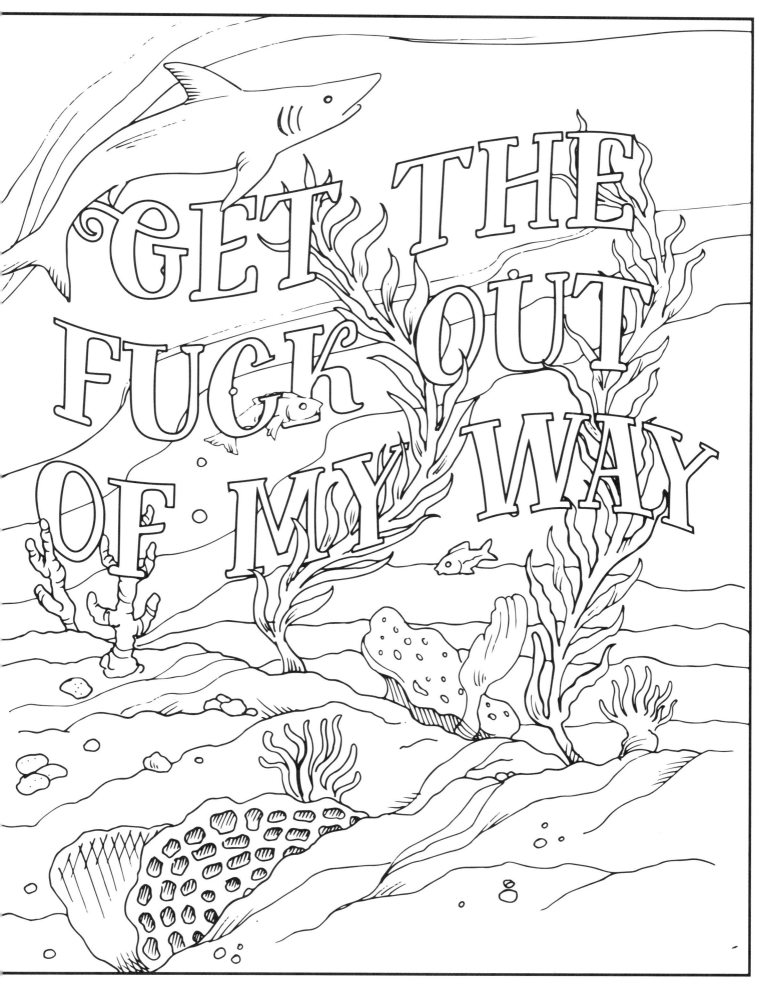

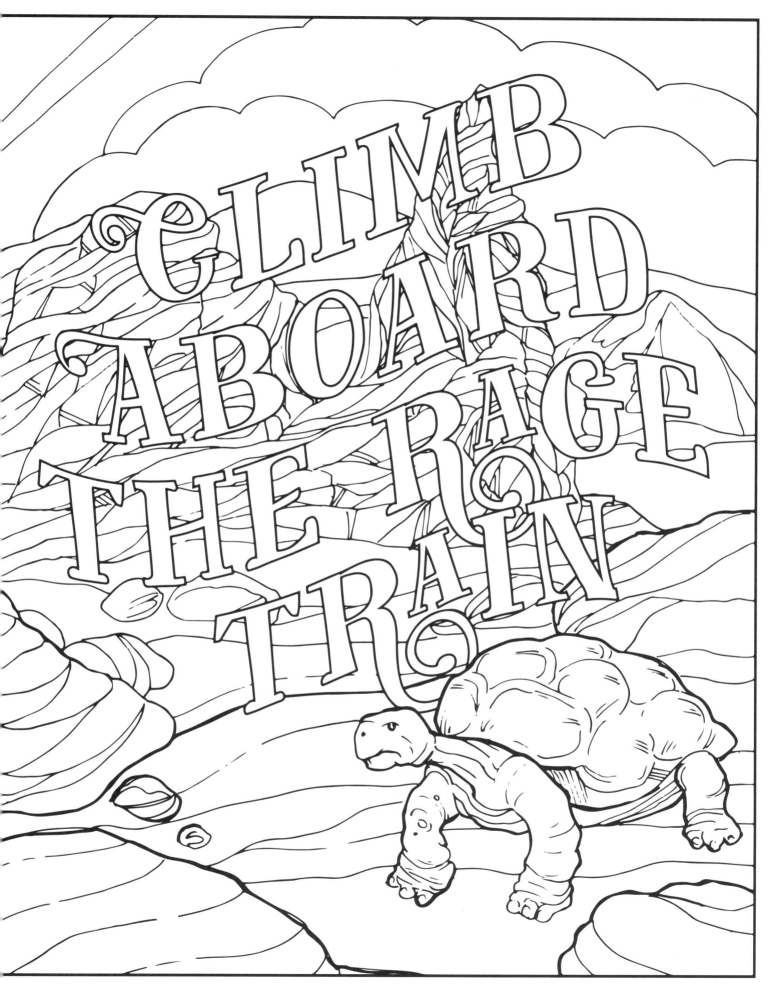

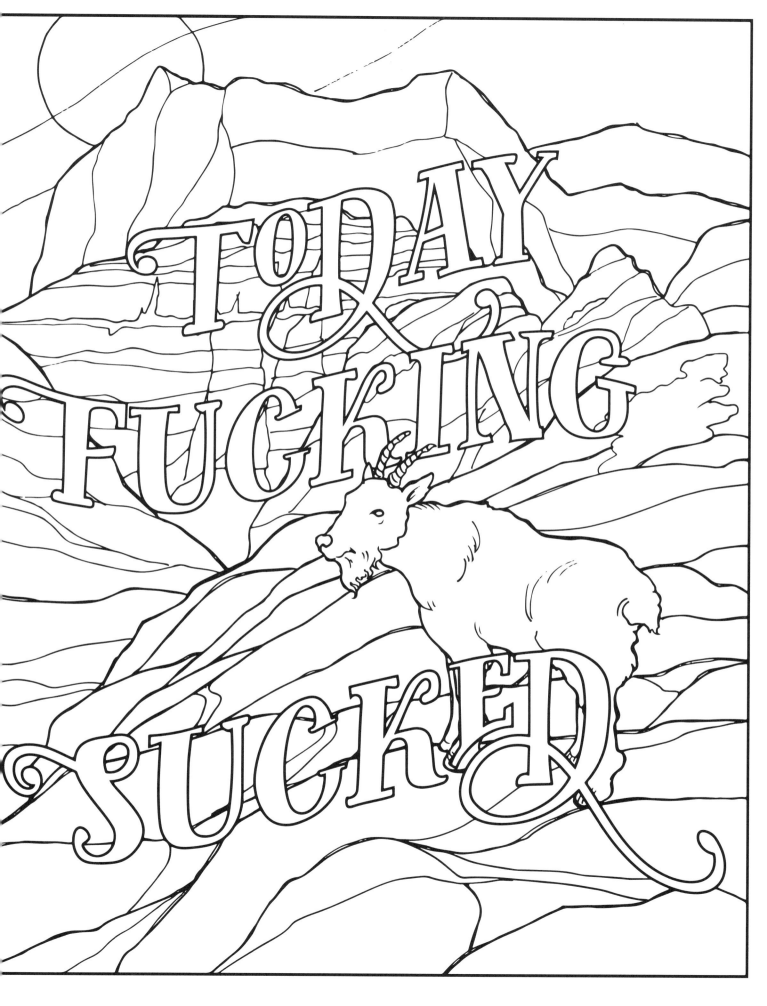

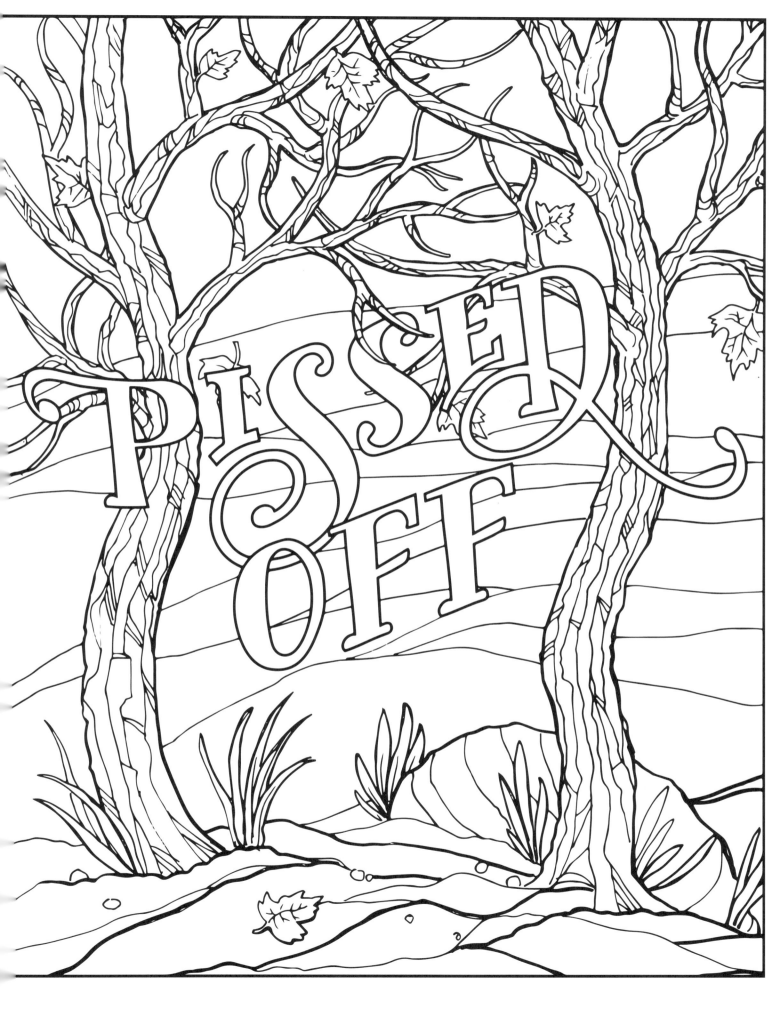

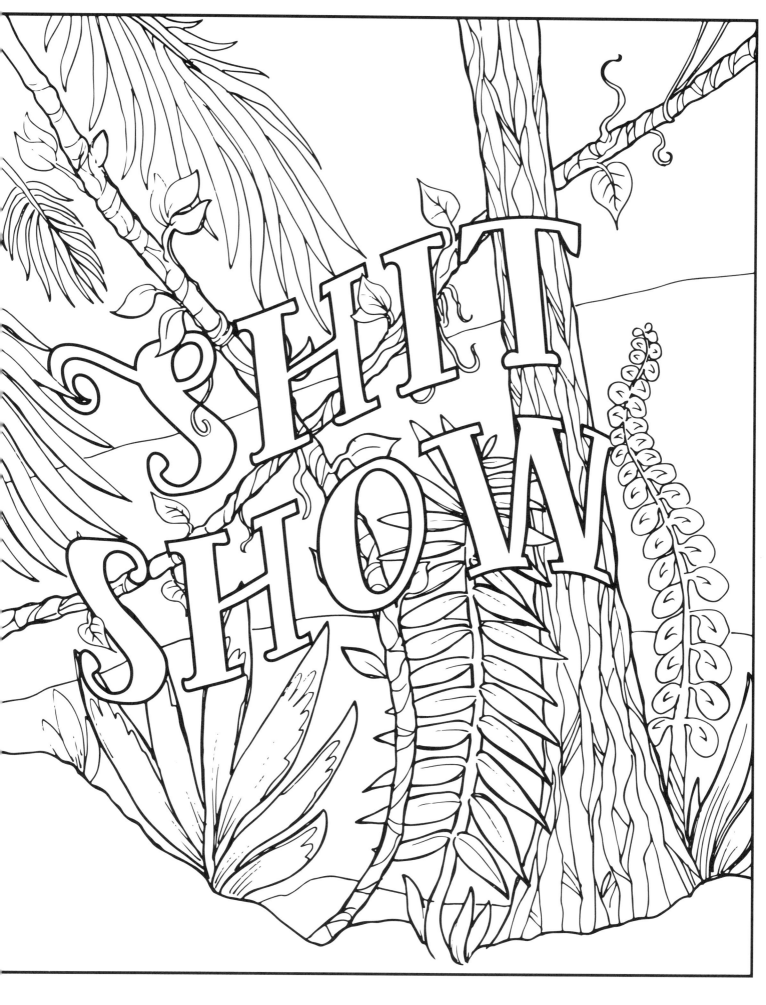

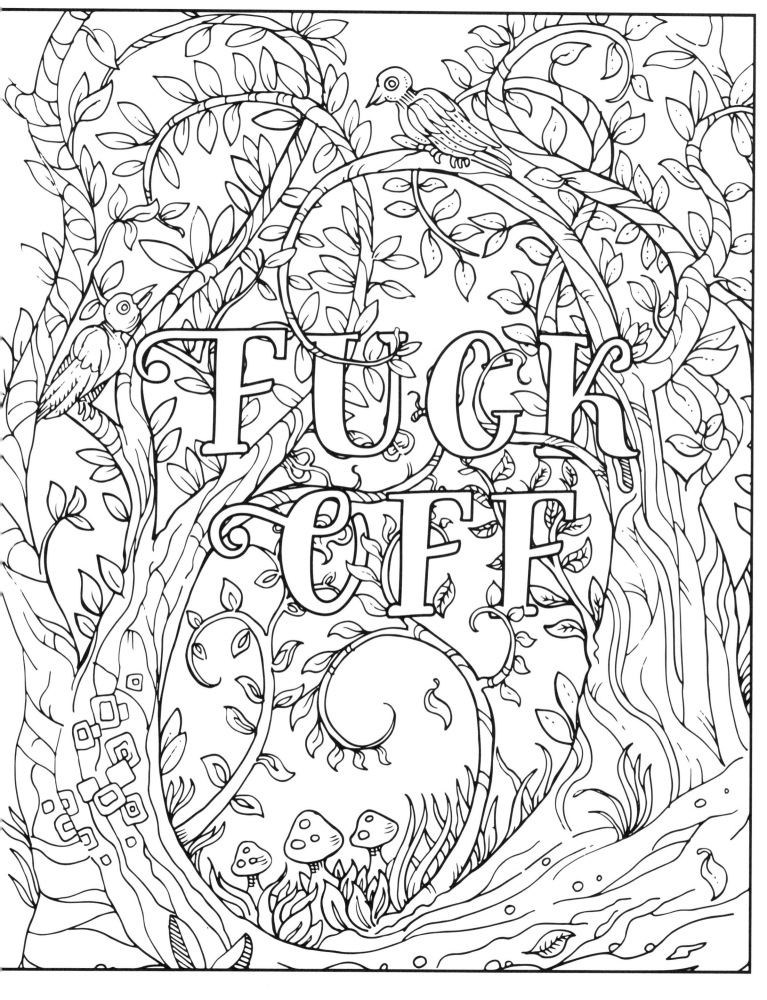

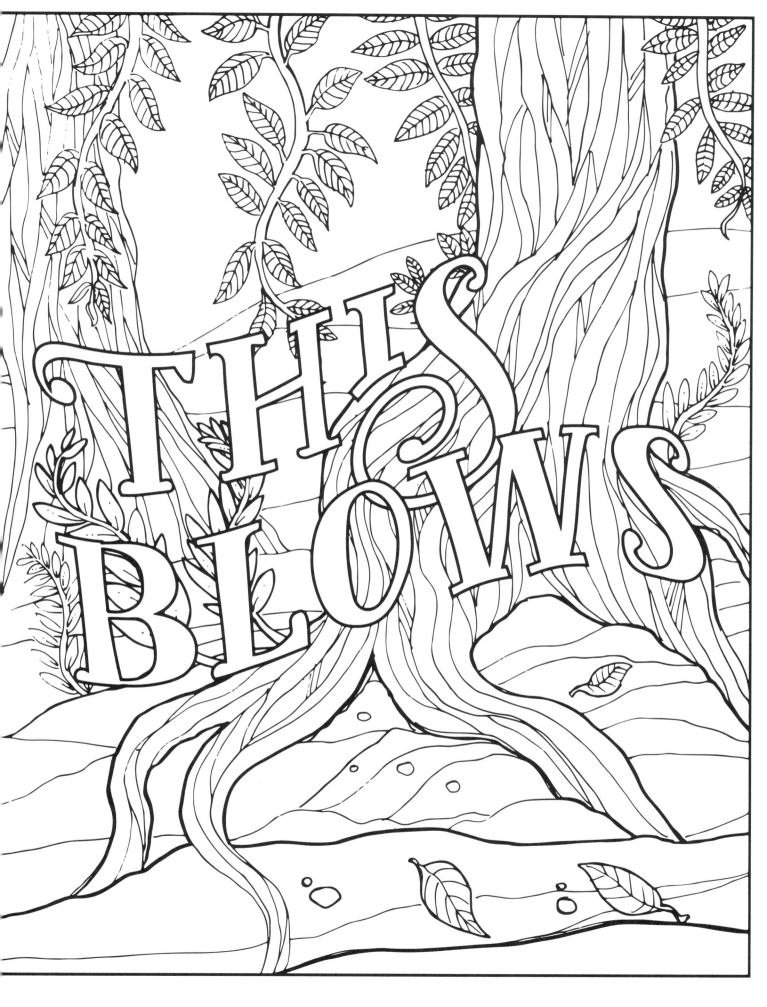

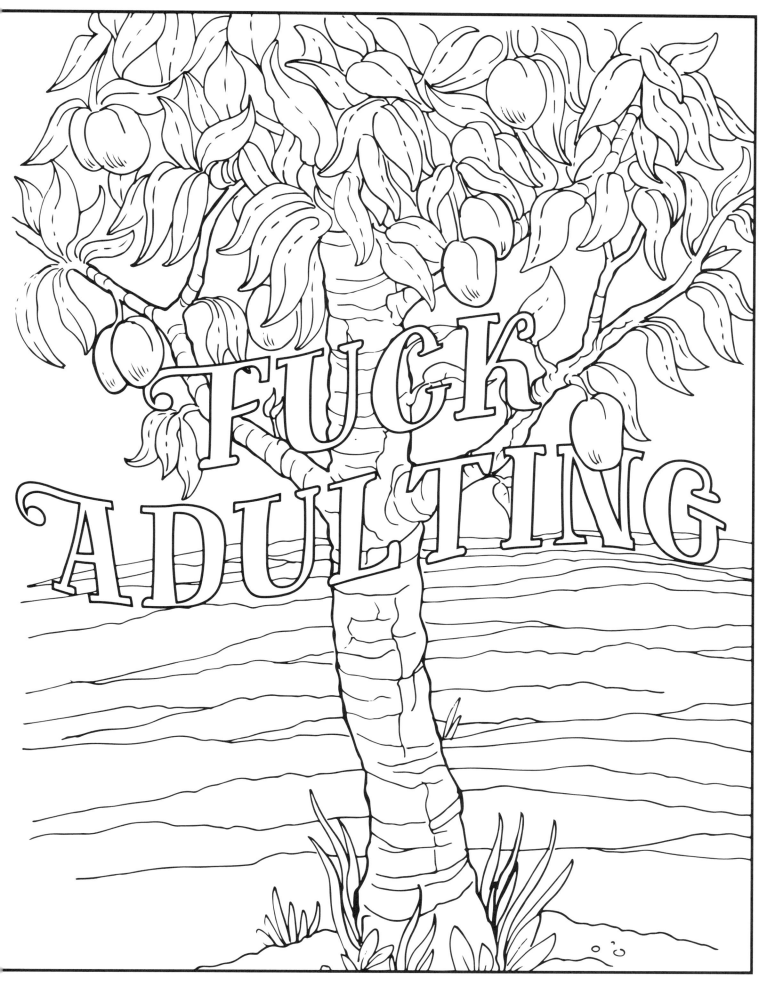

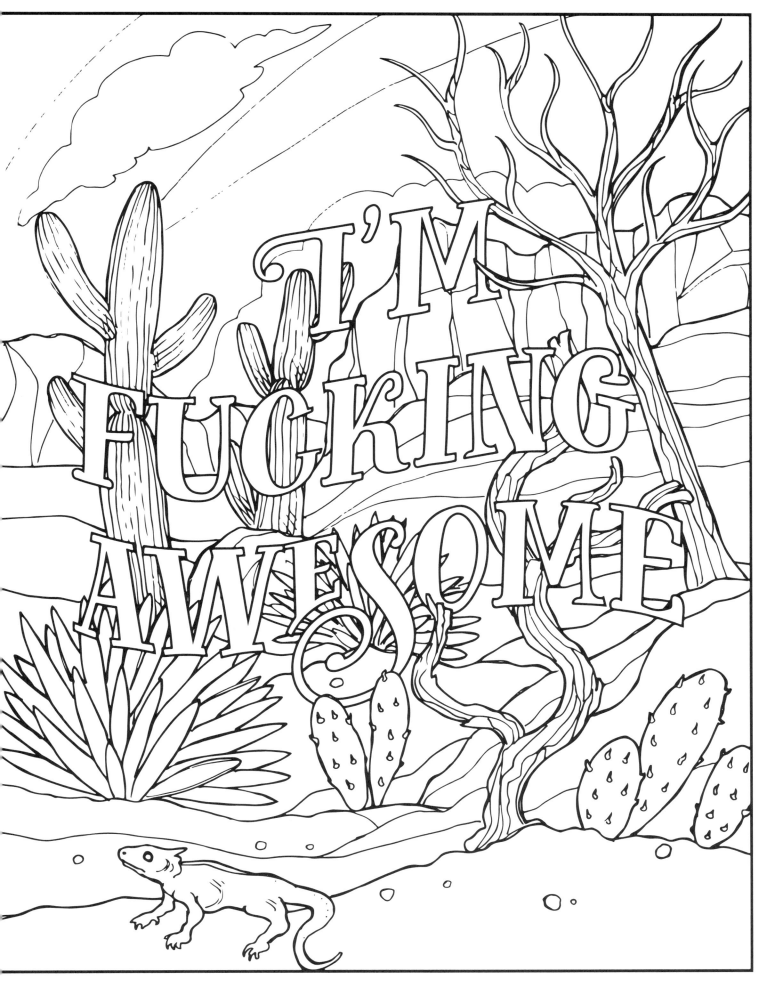

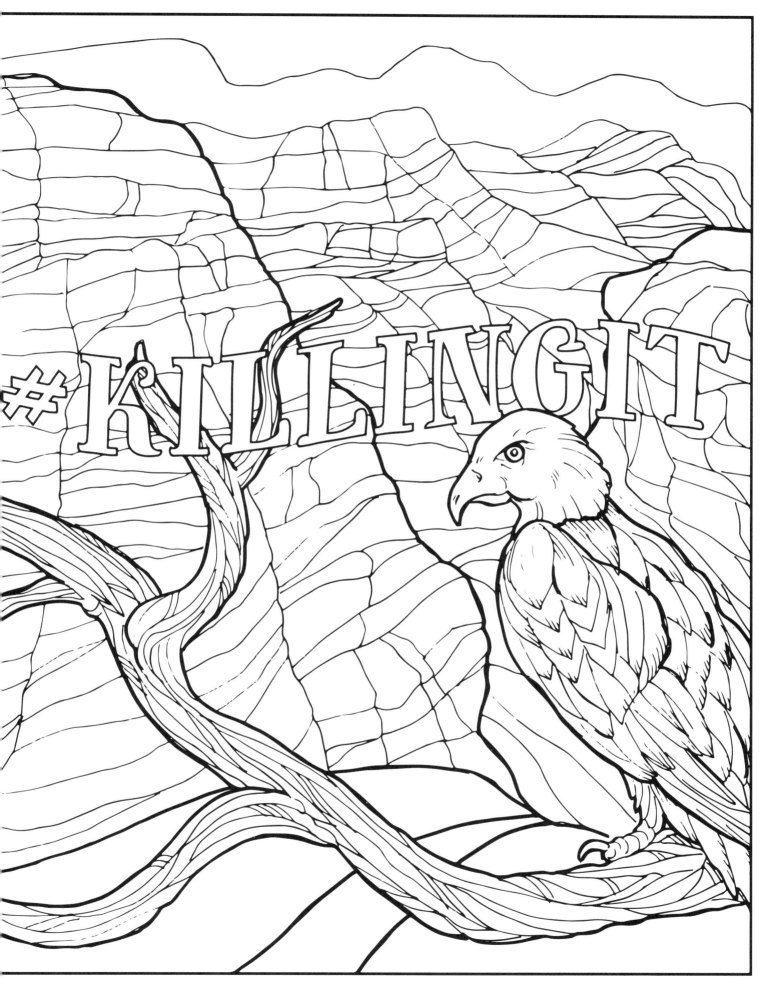

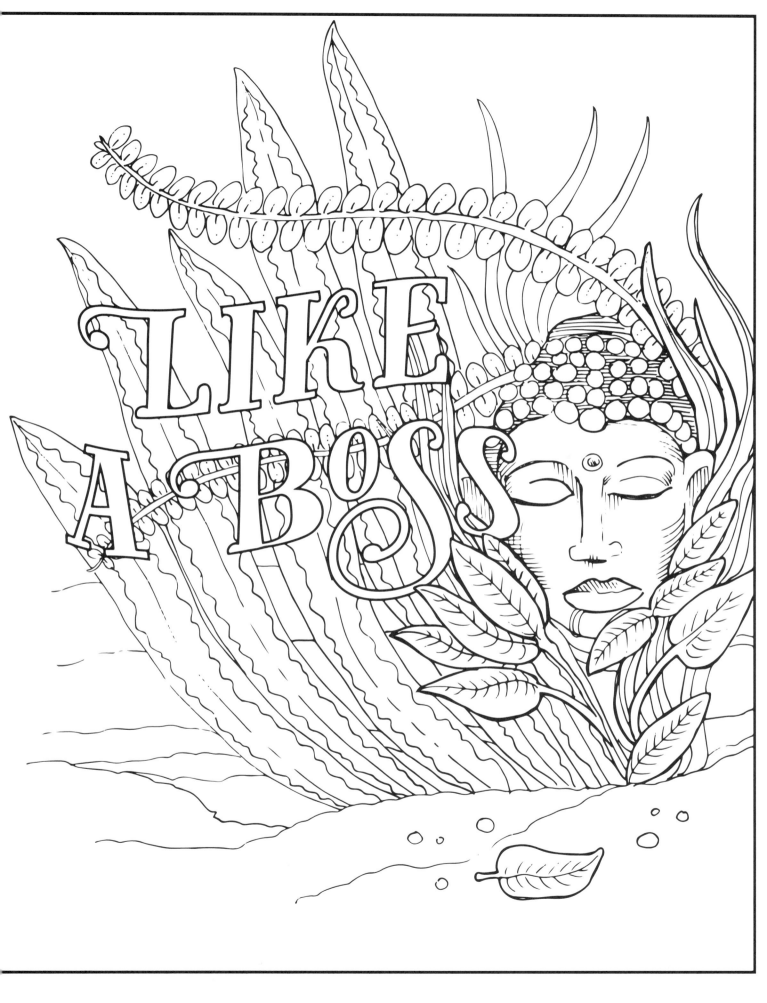

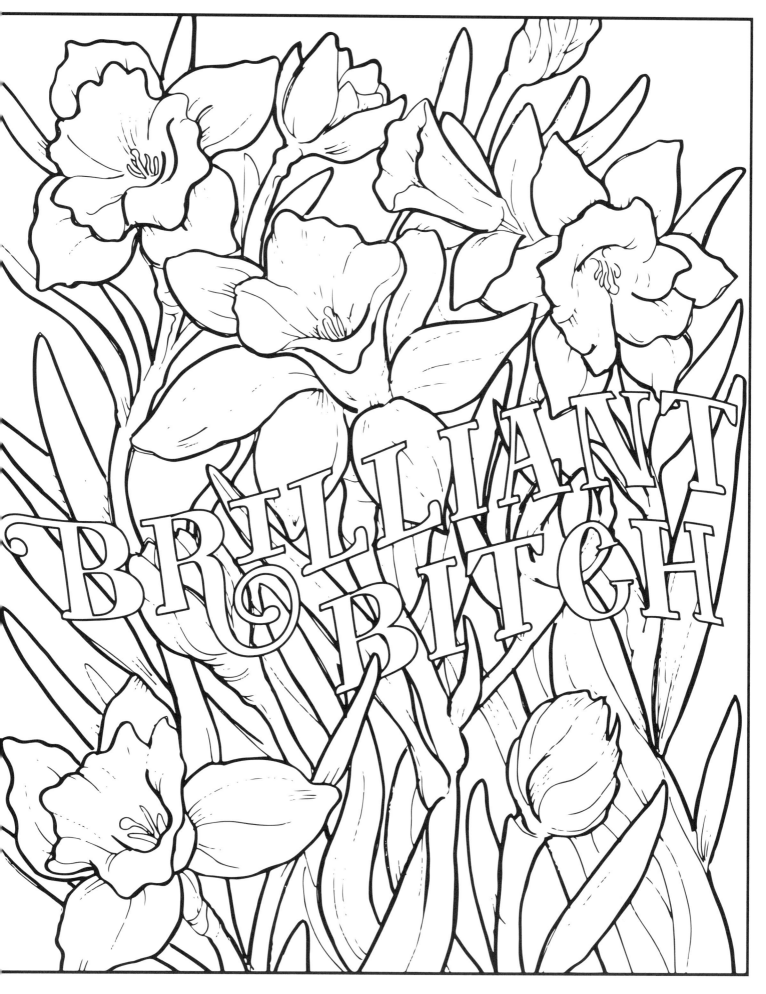

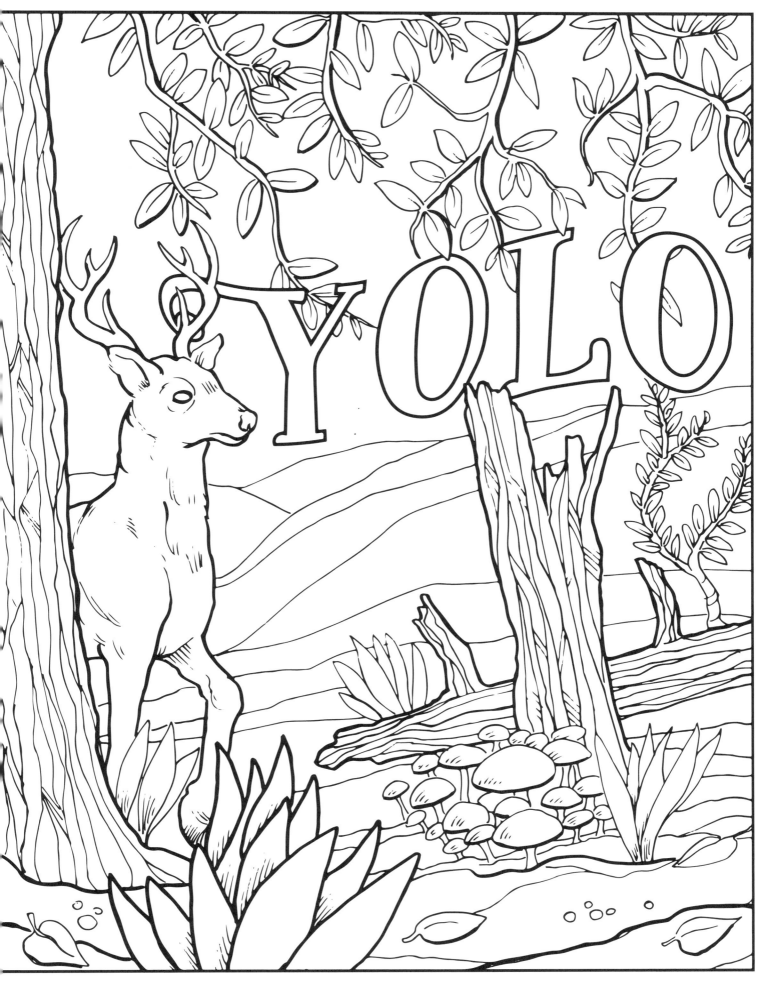

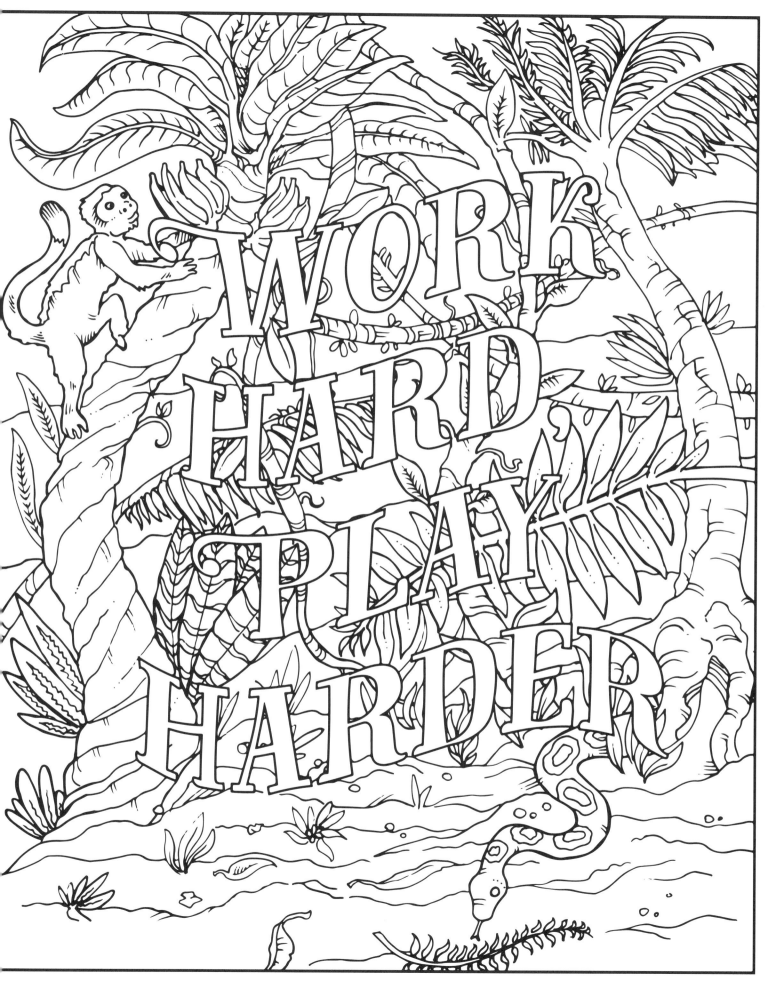

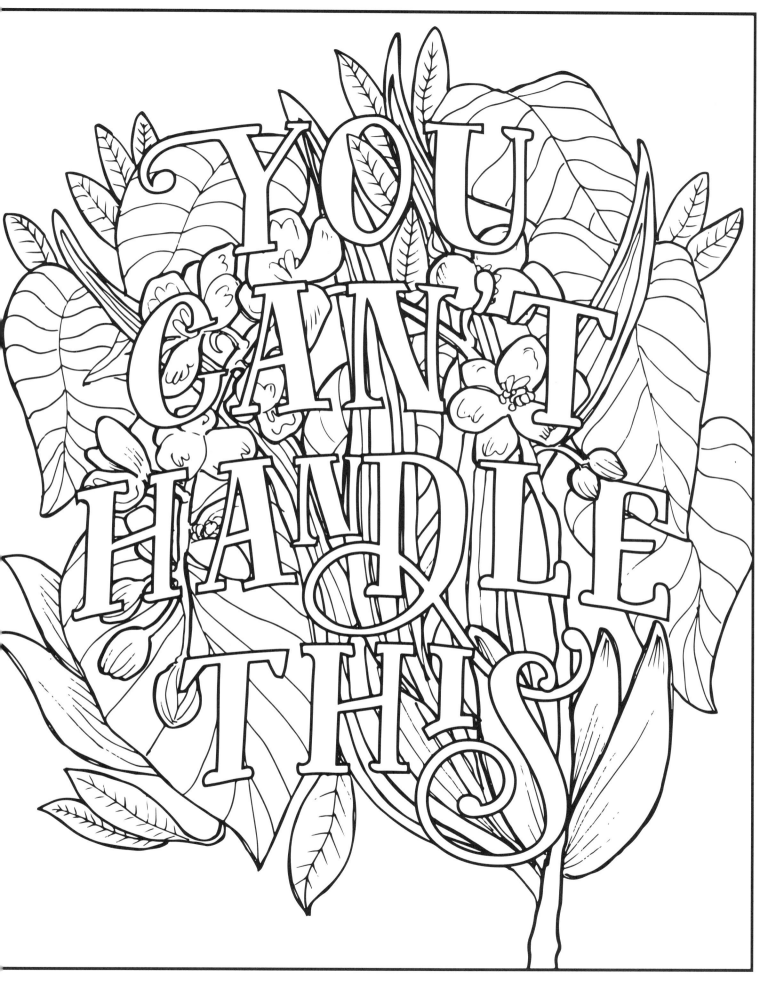

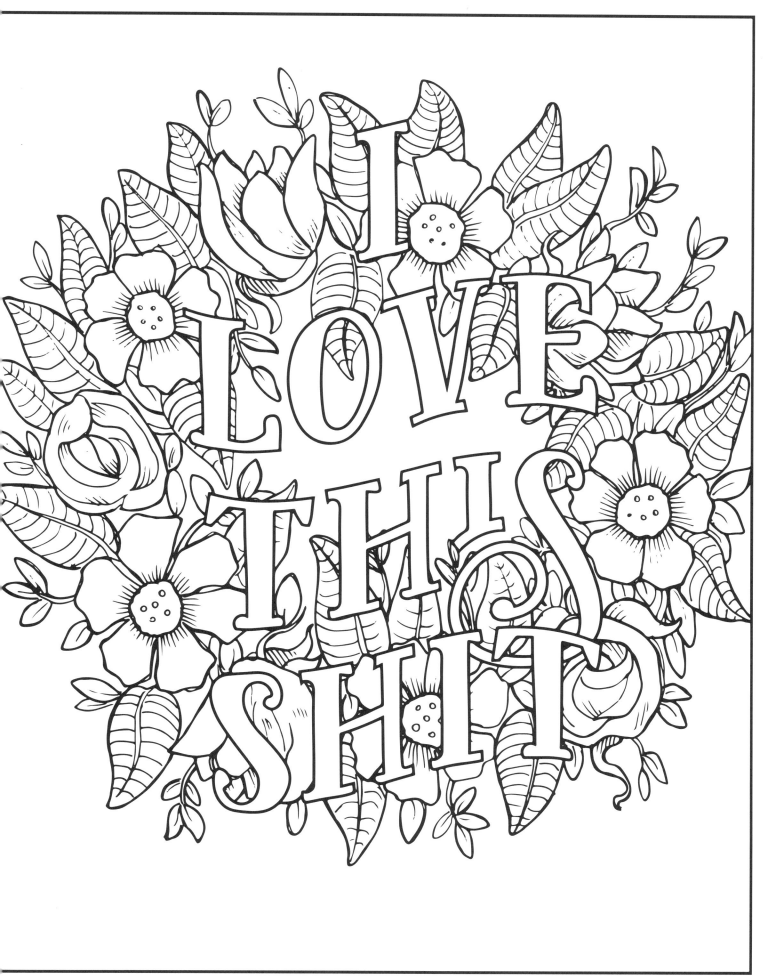

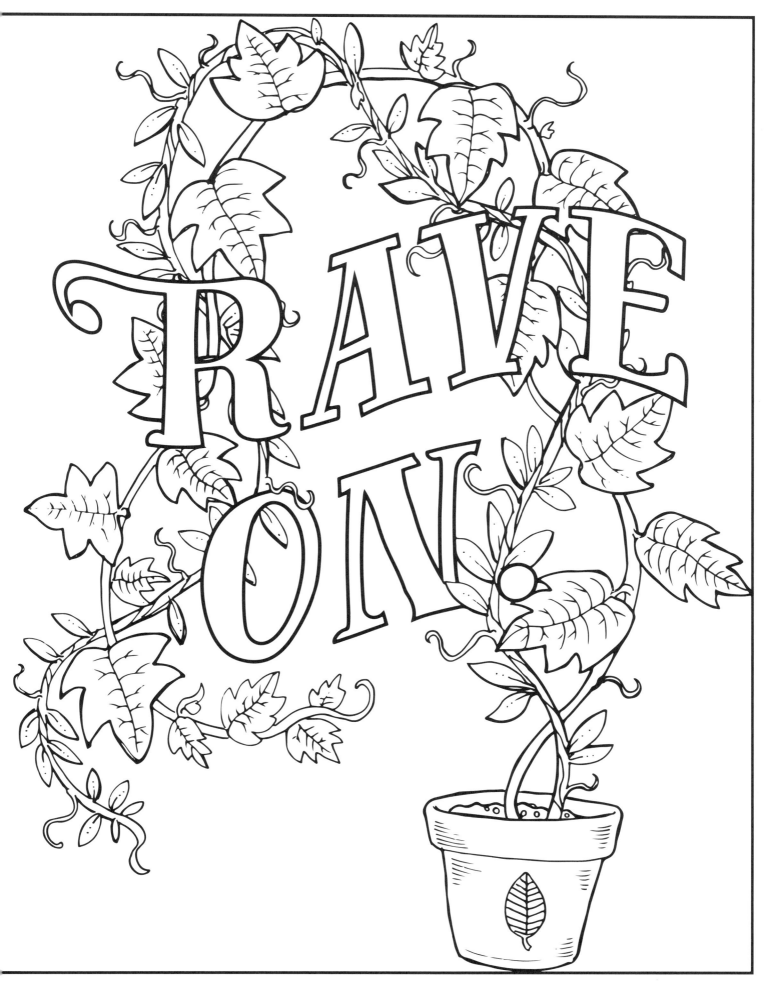

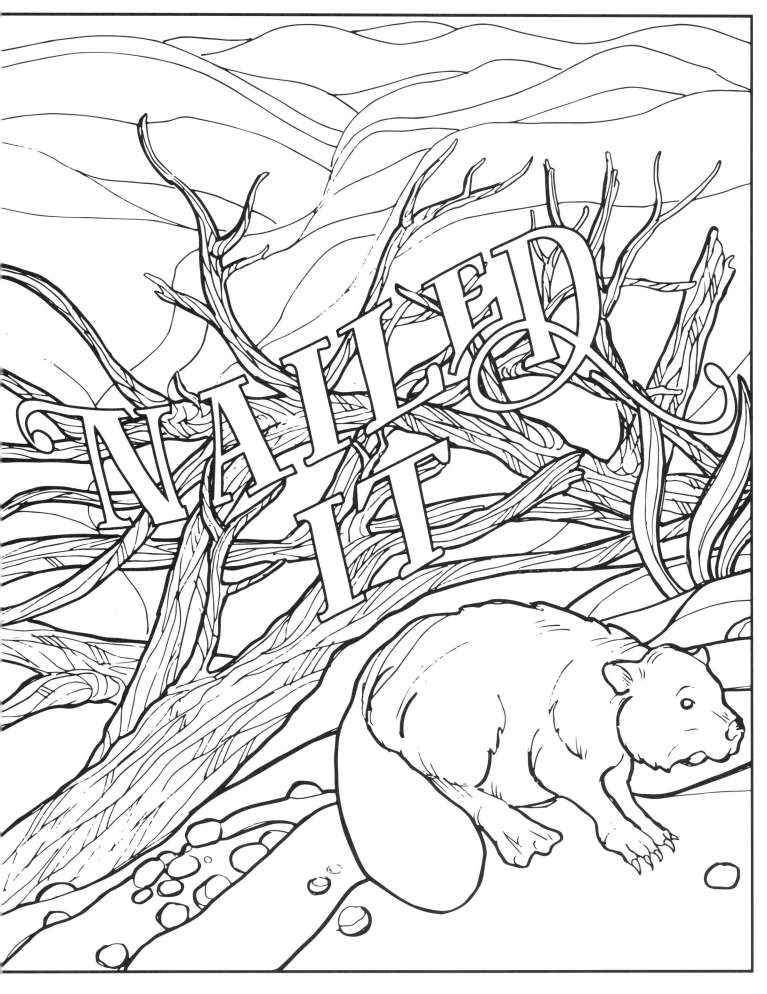

#FUCKOFFIMCOLORING #FUCKOFFIMCOLORING
#FUCKOFFIMCOLORING #FUCKOFFIMCOLORING
#FUCKOFFIMCOLORING #FUCKOFFIMCOLORING
#FUCKOFFIMCOLORING #FUCKOFFIMCOLORING
#FUCKOFFIMCOLORING #FUCKOFFIMCOLORING
#FUCKOFFIMCOLORING #FUCKOFFIMCOLORING
#FUCKOFFIMCOLORING #FUCKOFFIMCOLORING
#FUCKOFFIMCOLORING #FUCKOFFIMCOLORING
#FUCKOFFIMCOLORING #FUCKOFFIMCOLORING
#FUCKOFFIMCOLORING #FUCKOFFIMCOLORING
#FUCKOFFIMCOLORING #FUCKOFFIMCOLORING
#FUCKOFFIMCOLORING #FUCKOFFIMCOLORING
#FUCKOFFIMCOLORING #FUCKOFFIMCOLORING
#FUCKOFFIMCOLORING #FUCKOFFIMCOLORING
#FUCKOFFIMCOLORING #FUCKOFFIMCOLORING
#FUCKOFFIMCOLORING #FUCKOFFIMCOLORING
#FUCKOFFIMCOLORING #FUCKOFFIMCOLORING
#FUCKOFFIMCOLORING #FUCKOFFIMCOLORING

SHARE YOUR BADASS MASTERPIECES

As you fill in each colorful phrase, don't keep it to yourself—let the good feelings fly! Snap a pic, add the hashtag #FuckOffImColoring, and tag us on social media (@cidermillpress)—we can't wait to climb aboard your rage train and enjoy the ride!

INDEX

ABOUT CIDER MILL PRESS BOOK PUBLISHERS

Good ideas ripen with time. From seed to harvest,
Cider Mill Press brings fine reading, information, and
entertainment together between the covers of its creatively
crafted books. Our Cider Mill bears fruit twice a year,
publishing a new crop of titles each spring and fall.

"Where Good Books Are Ready for Press"

Visit us on the Web at
www.cidermillpress.com
or write to us at
PO Box 454
12 Spring Street
Kennebunkport, Maine 04046